DragonArt

FANTASY CHARACTERS

J "NeonDragon" Peffer

IMPACT
CINCINNATI, OHIO
www.impact-books.com

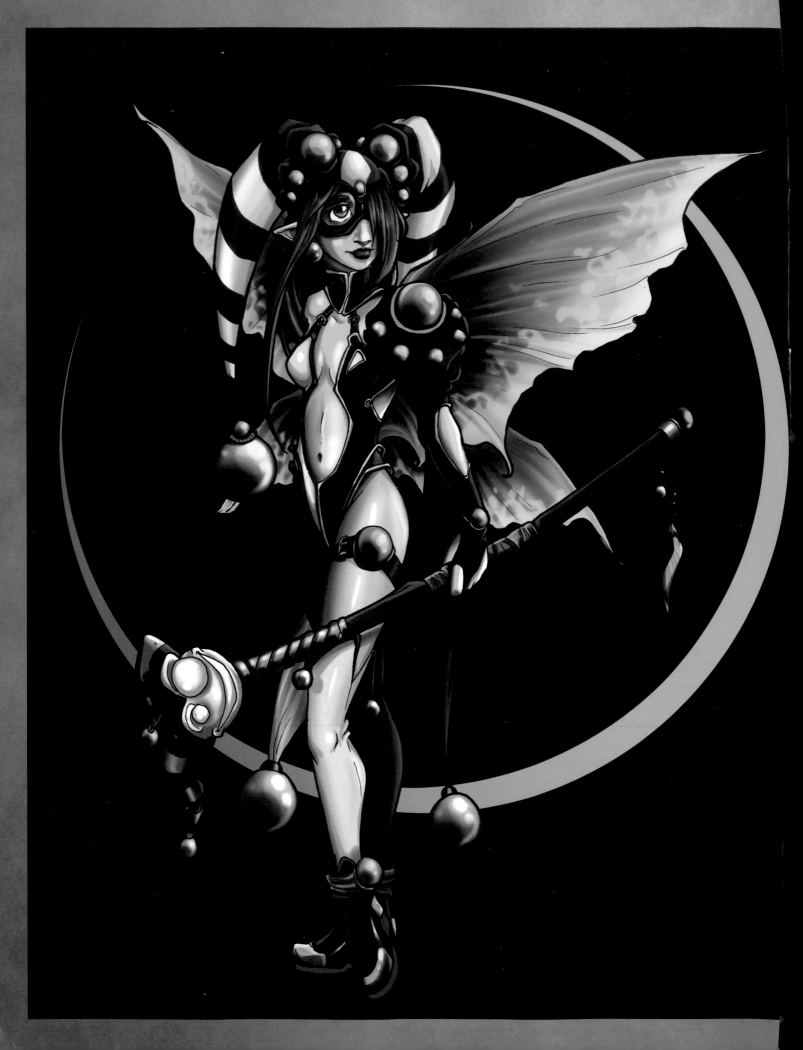

DragonArt

FANTASY CHARACTERS

How to Draw Fantastic Beings and Incredible Creatures

J "NeonDragon" Peffer

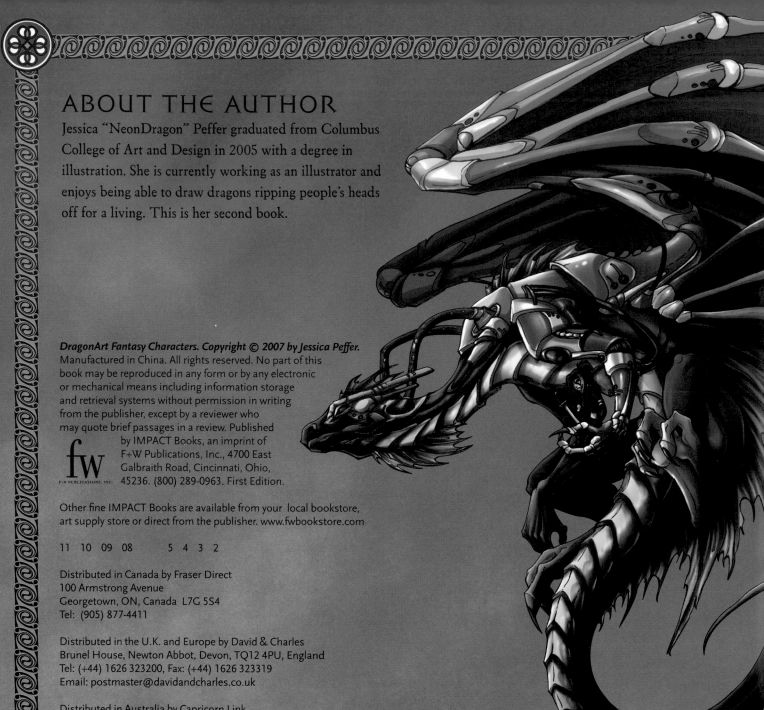

ABOUT THE AUTHOR

Jessica "NeonDragon" Peffer graduated from Columbus College of Art and Design in 2005 with a degree in illustration. She is currently working as an illustrator and enjoys being able to draw dragons ripping people's heads off for a living. This is her second book.

DragonArt Fantasy Characters. Copyright © 2007 by Jessica Peffer. Manufactured in China. All rights reserved. No part of this book may be reproduced in any form or by any electronic or mechanical means including information storage and retrieval systems without permission in writing from the publisher, except by a reviewer who may quote brief passages in a review. Published by IMPACT Books, an imprint of F+W Publications, Inc., 4700 East Galbraith Road, Cincinnati, Ohio, 45236. (800) 289-0963. First Edition.

fw
F-W PUBLICATIONS, INC.

Other fine IMPACT Books are available from your local bookstore, art supply store or direct from the publisher. www.fwbookstore.com

11 10 09 08 5 4 3 2

Distributed in Canada by Fraser Direct
100 Armstrong Avenue
Georgetown, ON, Canada L7G 5S4
Tel: (905) 877-4411

Distributed in the U.K. and Europe by David & Charles
Brunel House, Newton Abbot, Devon, TQ12 4PU, England
Tel: (+44) 1626 323200, Fax: (+44) 1626 323319
Email: postmaster@davidandcharles.co.uk

Distributed in Australia by Capricorn Link
P.O. Box 704, S. Windsor NSW, 2756 Australia
Tel: (02) 4577-3555

Library of Congress Cataloging-in-Publication Data

Peffer, Jessica.
 Dragonart Fantasy Characters: How to Draw Fantastic Beings
 and Incredible Creatures / Jessica Peffer. -- 1st ed.
 p. cm.
 ISBN-10: 1-58180-852-6
 ISBN-13: 978-1-58180-852-0 (pbk.)
 1. Fantasy in art. 2. Drawing--Technique. I. Title.
 NC825.F25P44 2007
 743'.87--dc22
 2007001838

EDITED BY Kelly C. Messerly & Mary Burzlaff
DESIGNED BY Jennifer Hoffman
PRODUCTION COORDINATED BY Jennifer W. Menner & Matt Wagner

METRIC CONVERSION CHART

TO CONVERT	TO	MULTIPLY BY
INCHES	CENTIMETERS	2.54
CENTIMETERS	INCHES	0.4
FEET	CENTIMETERS	30.5
CENTIMETERS	FEET	0.03
YARDS	METERS	0.9
METERS	YARDS	1.1

ACKNOWLEDGMENTS

I'd like to use this 6" × 3" (15cm × 8cm) block of text to thank my family for all of their love, support and the bountiful supply of Coca-Cola. (This includes my two sisters, Megan and Shauna, who I forgot to mention in DragonArt. There! You happy now?) Many thanks go out to my editor, Kelly Messerly, for making me sound like I might have some vague idea what I'm talking about, and to Jennifer Hoffman, for making the chaos of illustrations I threw at her into the neat, orderly glory you see before you.

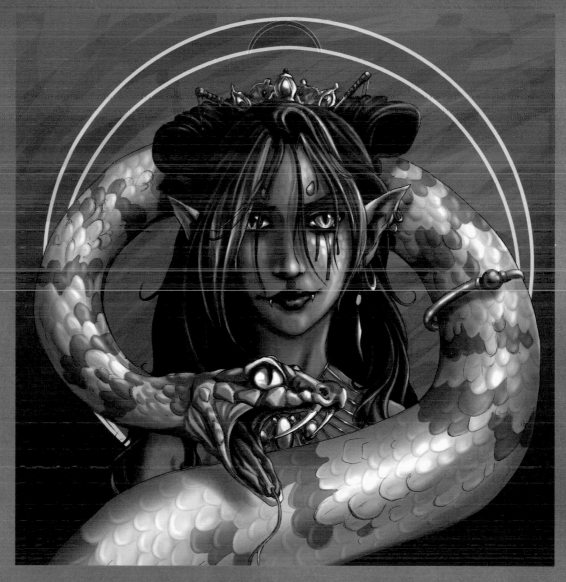

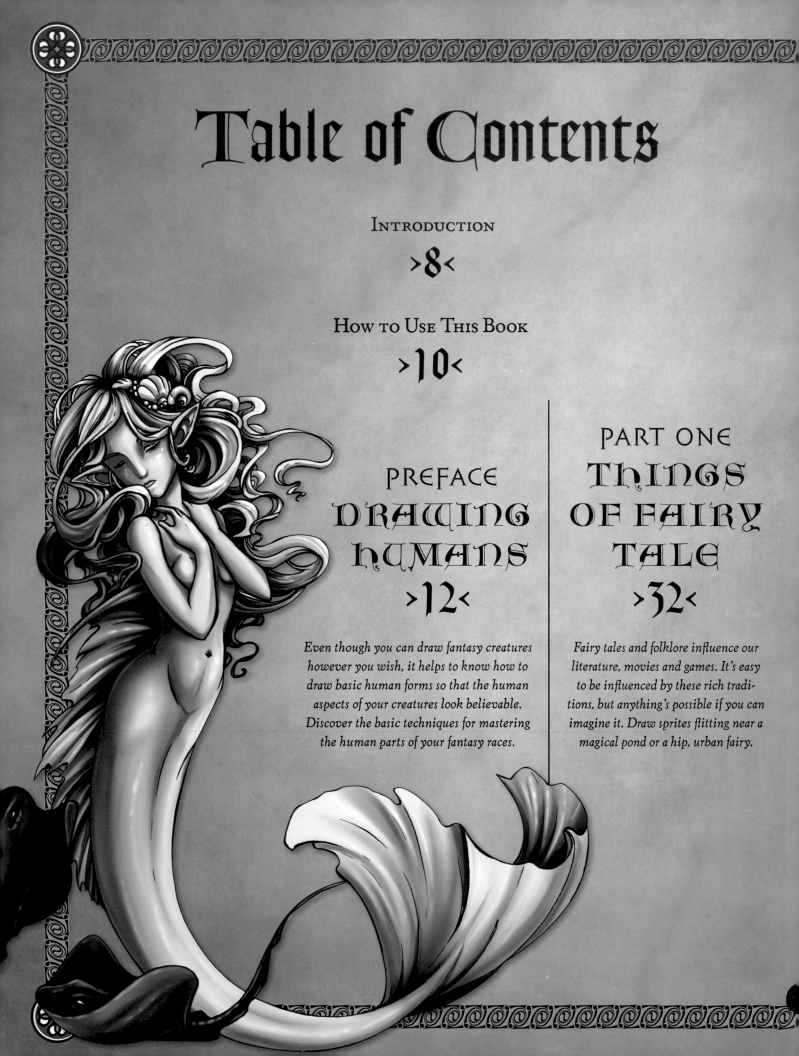

Table of Contents

Even though you can draw fantasy creatures however you wish, it helps to know how to draw basic human forms so that the human aspects of your creatures look believable. Discover the basic techniques for mastering the human parts of your fantasy races.

Fairy tales and folklore influence our literature, movies and games. It's easy to be influenced by these rich traditions, but anything's possible if you can imagine it. Draw sprites flitting near a magical pond or a hip, urban fairy.

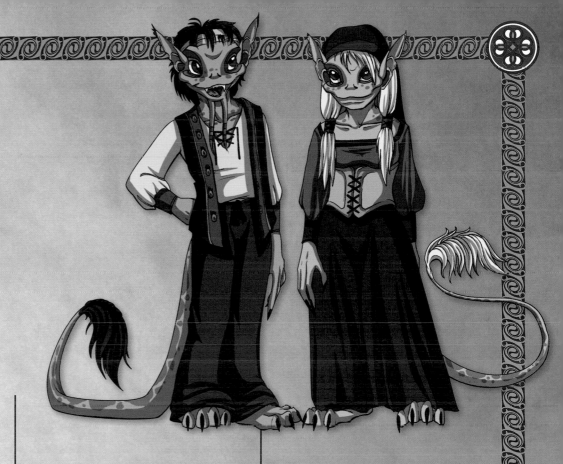

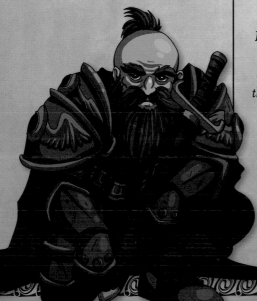

Introduction

Fantasy is one of the most exciting genres to draw for. There are no rules and anything is possible. You can stick to the established conventions already out there, or let your imagination run wild.

Fantasy worlds aren't just populated with sensational monsters. They're full of equally fantastical races of people. Heroes, villains, and the everyday person can be anything and everything you can imagine.

Your fantasy world can be a realm of medieval mayhem, wayward peasants fighting evil sorcerers to save that elusive princess. Maybe you don't want to stick to a preestablished convention; your fantasy world could be a mix of modern technology and magical creatures. Maybe your world is full of bits and pieces of several different myths, combined with something uniquely your own.

With all the variety in characters, costumes, monsters and environments, fantasy is a genre that can keep you interested with enough new and exciting things to imagine and create for a lifetime!

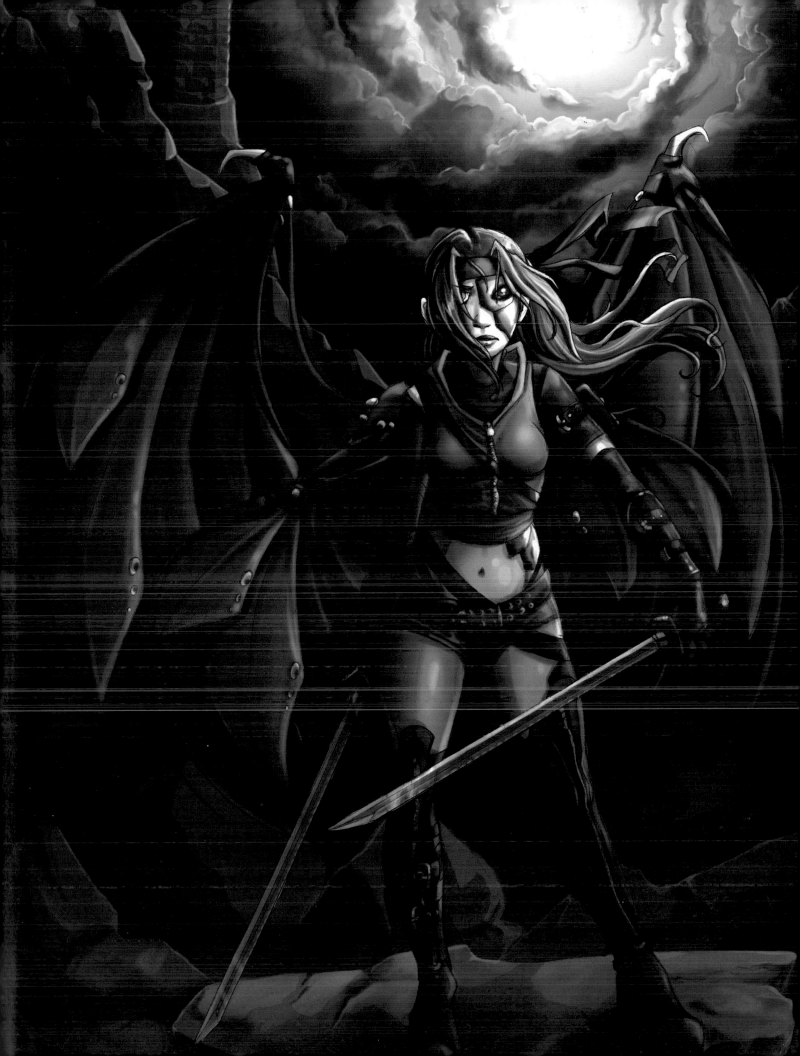

How to Use This Book

Fantasy creatures, by their very nature, have no firm blueprints. In made-up worlds, rules are made to be broken. However, the creatures all share some similar characteristics. Anatomy must be functional. By studying each piece of the anatomy and understanding how it works, you'll learn to build your own characters.

This book consists mainly of easy-to-follow step-by-step demonstrations. Each new step of each demonstration is denoted in red. Following along with the demonstrations will help you draw several different, truly fantastic creatures. Look out for Dolosus, your fierce dragon guide, and Harold, his incompetent minion, along the way, too. They show up here and there to provide helpful tips and tricks to ease your passage.

Don't be discouraged if your first efforts don't look exactly as you planned. Everything comes with practice. The more you draw, the better you'll get. Through sheer repetition, your drawings will improve and your own personal style will emerge. If each drawing you make looks a little bit better than the previous one, you're getting somewhere.

So sharpen your pencils, find your softest eraser, prepare your trusty inking pen, and let's go!

>1<

Begin with a line of motion.

Then add lanky, stretched-out boxes to indicate the head, chest and hips.

>2<

Draw dimensional lines to connect the chest and hips.

Using simple line-and-circle construction, sketch in the arms.

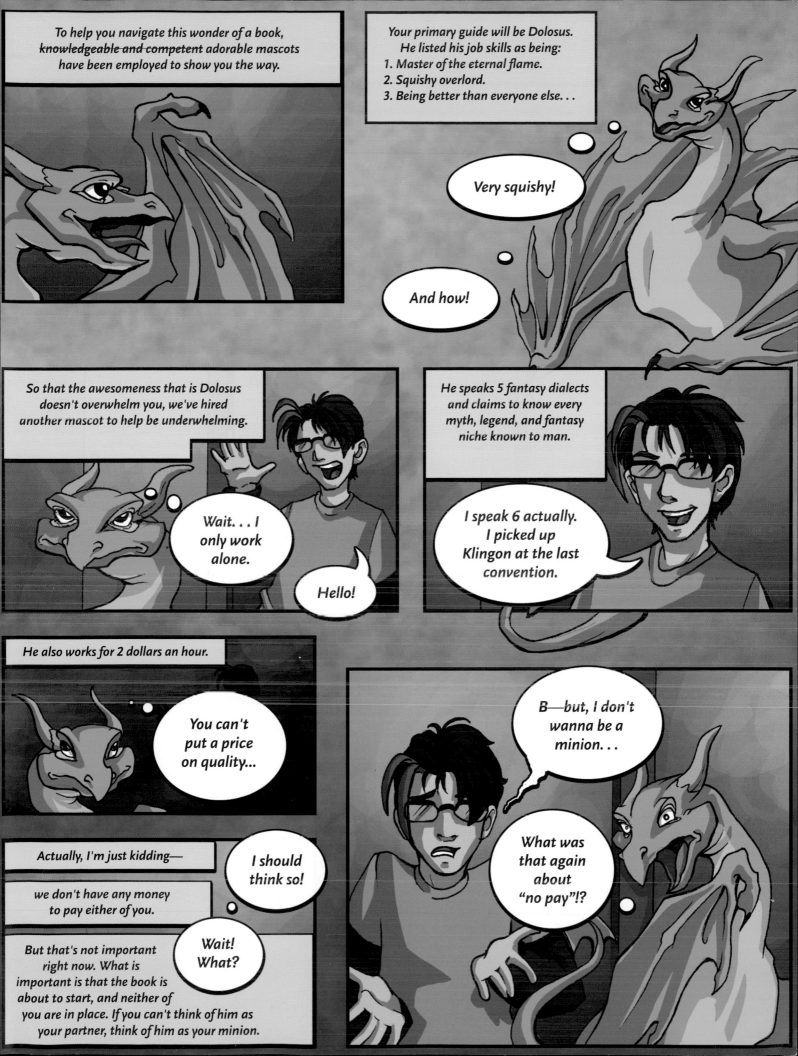

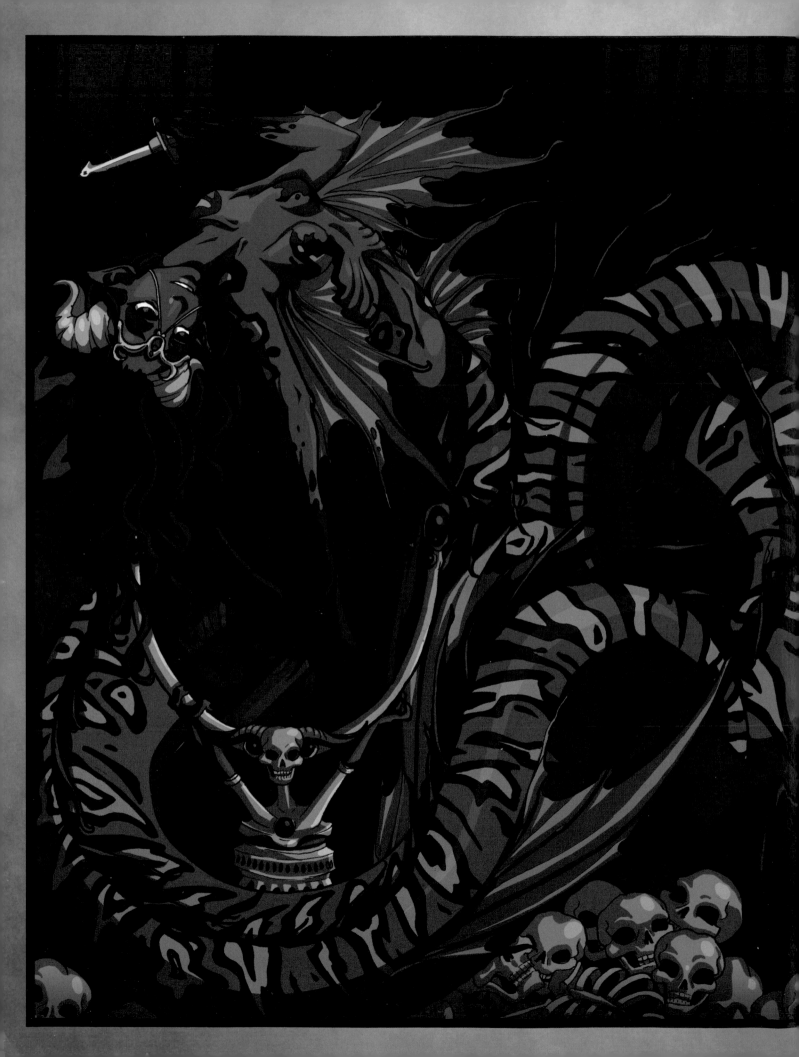

Drawing Humans

While fantasy monsters and magic turnips are all well and good, most people will want their stories to center around more humanlike creatures. We find it easy to relate to humans because we know them best.

Humans are a fantastic tool for visual storytelling because we can tell at a glance what a facial expression or gesture is trying to convey. This allows you, as the artist, to tell a story with only a few subtle touches.

One problem that drawing creatures based on human beings presents is that we know humans so well. We see them every day. If something is just a little bit off, you'll be able to spot it at a glance. With enough practice drawing the form, you will learn how to fix these problems. As you practice, stick to a very regular and measured set of proportions and use a loose skeleton underneath your drawings to get it right.

The same technique will work for fantasy creatures based on humans. Even though, as fantasy creatures, you can draw them however you wish, it helps to know how to draw basic human forms so that the human aspects of your creatures look believable. The following pages contain some basic techniques for mastering the human parts of your fantasy races.

BASIC SHAPES

First things first. Before you can dive into drawing beautiful beasts, you need to arm yourself with some drawing basics. The easiest way to think about drawing anything is to think of everything as shapes. Anything you would ever want to draw—tables, chairs, flowers or unicorns—consists of simple shapes.

BASIC SHAPES LEAD TO FANTASTIC CHARACTERS
Practice drawing these simple shapes before moving on to more complicated forms.

DRAWING ANY CREATURE BEGINS WITH BASIC SHAPES
Every creature you'll learn about in the pages to follow will begin with simple shapes such as these.

TOOLS YOU NEED

The wonderful thing about drawing is that you really don't need much—your own imagination is the most important thing. To get what's in your head down on paper, though, you will need:

some pencils
a pencil sharpener
a kneaded eraser
paper

That's all that's required to propel yourself into fantasy creature creation readiness!

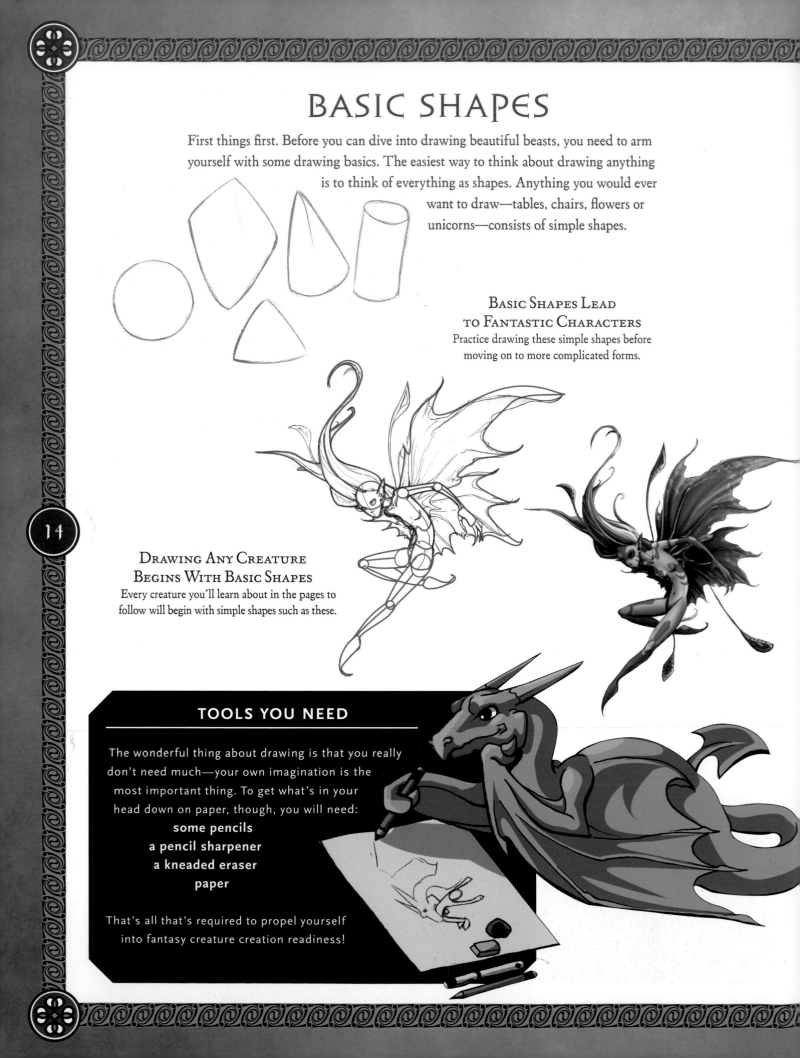

SHADING AND 3-D EFFECTS

Fantasy characters appear more realistic when you draw them to look three-dimensional. It isn't as hard as it sounds. You just have to pay attention to darks and lights and how they affect your creature.

Consider first where the light is coming from. This is called the light source. Where the light source hits your dragon or other object is the lightest spot, called the highlight. The rest of your creature will likely be in some stage of shadow. As you develop your skills at shading the shadow areas, your creatures will begin to take on new life.

PRACTICE ON SIMPLE SHAPES

Polygons (shapes with three or more sides) will often have one side facing the light source. This side will be considerably lighter than those angled in a different direction. Sides that are completely cut off from the light will be very dark, giving you a harsh edge.

With round objects there is no clear definition of where things get cut off from direct light. The answer to this problem is fairly simple: Because there's a gradual cutoff from the light, you will have gradual shadow with no harsh edges. Figure out where your light is hitting directly, and as things move farther away from that point of light, they should get darker.

SIMPLE PENCIL TECHNIQUES FOR SHADING

1 Scribble—Swirl your pencil in overlapping circles.

2 Stipple—Place dots close together or far apart.

3 Crosshatching—Lay hatch marks, one over the other.

4 Hatching—Place short lines close together or far apart.

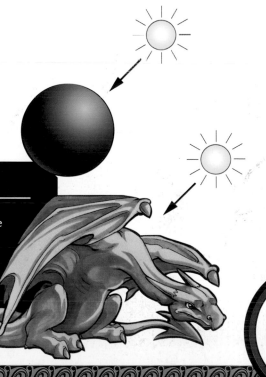

BE AWARE OF THE LIGHT SOURCE

As cool as fantasy characters are, they remain solid, tangible objects that follow the same laws as everything else when it comes to light source. Lighting that comes from a single direction will yield highlights on the surfaces that it hits, and shadows on the areas blocked off from the rays.

PENCILING AND INKING

You may want to keep your pencil lines very soft and natural looking, and just paint right on top of them, so in the end you have no linework at all. Inking your drawing is an equally interesting approach. An inked drawing makes your character very crisp and clean, and will make coloring much easier later on, as you've already begun defining your character. Inking also makes line cleanup easy. Just draw all your construction lines in pencil, then do your finals in ink. When you're finished, go back in with an eraser and rub it over the entire drawing, leaving only the final ink lines behind.

A ballpoint pen will give you a finer, more varied ink line than markers, but watch for smudging! Some ballpoint pens leave unequal amounts of ink in a line, causing much grief later on. Markers are not always the best solution either because they are very susceptible to bleeding. Many art stores carry disposable technical pens that are ideal for starting out with inks. They are fairly cheap, come in different colors and are easy to use.

PENCIL
Pencil lines are light and easy to cover with ink or paint. If you would like your pencil lines to show, you can use a mechanical pencil to tighten up your linework. Then, you can take it into your favorite computer program and color it. If you leave your pencil drawing as is, you can easily shade it with a variety of soft and hard leads.

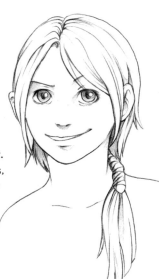

BALLPOINT PEN
Ballpoint is nice because it's possible to do very light lines and shade as well. You can achieve delicate linework that is difficult to achieve with other inking tools. Compared to a pencil, though, erasing is difficult.

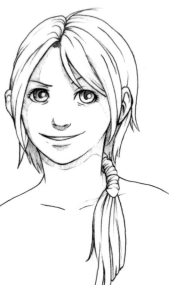

TECHNICAL PEN
Technical pens create very thin, sharp lines, perfect for comic books. Shading with liquid ink involves a series of line widths, hatching, stippling and cross-hatching. It's not possible to get a series of greys with the ink itself, because it will always come out black. Use a Micron pen if you want a clean unshaded drawing, or a drawing that's shaded using line-work with a lot of character.

BRUSHPEN
A brushpen allows you to create thick and thin organic lines. Your lines will never be as delicate or exact as those done with ballpoint or technical pens, but you can achieve a lot of character and inking speed with a brushpen.

COLORING

You can take several different approaches to color as you plan out your characters. Color combined with lighting sets the mood for any image. Desaturated colors and earth tones will give you a soft, natural-looking image. If you place some vibrant colors against mostly neutral colors, those vibrant colors will seem very bright, almost glowing. Vibrant colors set against a neonlike setting won't stand out as much. If you want your characters to really pop out from the page, color them just a touch more boldly than the background. Making good color choices will make your characters look believable. For instance, orange with pink and green polka dots may not be a great choice for a vampire's skin.

THE COLOR WHEEL

The color wheel is a great tool to help you plan out your character's color scheme. The primary colors are red, yellow and blue. The secondary colors are orange, green and purple. Complementary colors sit across from each other and analogous colors sit next to each other.

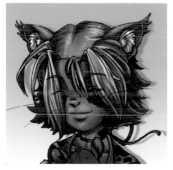

COLOR CHAOS
You can paint your character with a rainbow of colors, picking out the ones you like best and seeing where it goes. You don't have to follow a specific coloring strategy if you don't want to, but if you find your image isn't coming together how you would like, thinking ahead and using coloring strategy may be beneficial.

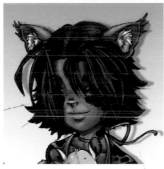

ANALOGOUS COLORS
Analogous colors, or families of colors, are colors that are next to each other on the color wheel. In this case, shades of red-orange, orange, and yellow-orange were used to color the image. This allows for more variety of color than a monochromatic image while still having your colors feel largely the same.

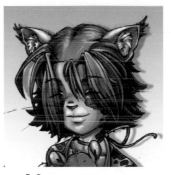

MONOCHROMATIC COLORS
A simple way to bring an image together is to use monochromatic colors. That is, you use varying shades and intensities of the same color. The colors will look like they belong together, because they are all the same hue. You can bring in little bits of other colors here and there for variety.

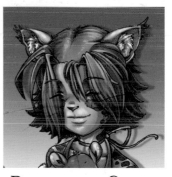

DESATURATED COLORS
Not all colors need to be bright. Just because your character's hair is pink doesn't mean it needs to be the pinkest pink available. Toning down all your colors will give you a more natural image and may help avoid rainbow chaos.

PERSPECTIVE AND OVERLAP

Overlap is a great tool for creating perspective, the illusion of space, and is arguably one of the more important aspects to creating drawings full of depth. When you draw one object or part of an object overlapping another, the object in front automatically looks closer while the one in the back looks farther away.

You can use overlapping objects to create a sense of perspective not only in individual characters but also in entire scenes. Draw a mountain, then a house overlapping it followed by a orc overlapping the house and you've got a foreground, middle ground and background. Once those are clearly defined, you've got a believable drawing.

Background

Middle ground

Foreground

OVERLAPPING DEFINES YOUR SPACE
Overlapping shapes help clearly define your foreground, middle ground and background and give friendly dragons like these a clear sense of solidity.

NO PERSPECTIVE OR OVERLAP
Without any overlap or perspective, it is difficult to get an idea of the scale of things. It is also difficult to think of the object as existing within a space. It's lost, floating on the paper.

OVERLAP GIVES A SENSE OF ORDER AND GROUND
Overlap provides a sense of space. The brain registers that one object must be in front of the other.

OVERLAP PLUS SIZE VARIATION PROVIDE MORE PERSPECTIVE
The green dragon is smaller than the brown. When we see it though, we don't think he's actually smaller then the brown. We just assume he's farther back in the space that they share.

OVERLAP PLUS SIZE VARIATION PLUS ATMOSPHERE EQUALS PERSPECTIVE TO THE MAX!
Atmospheric perspective means that things that are closer appear brighter, have greater contrast and look more in focus. As they recede, all these effects fade. Using all three perspective techniques gives the viewer a good sense of depth.

Drawing the human body can be frustrating at first. Because we see people every single day, our eyes know what the body looks like. Then, when we draw bodies, tiny mistakes or things that are slightly off jump right off the page and scream, "This is wrong! This is wrong!" Never fear. With enough practice and a few basic guidelines, you can avoid those mistakes and make drawing the human form much less painful, even fun.

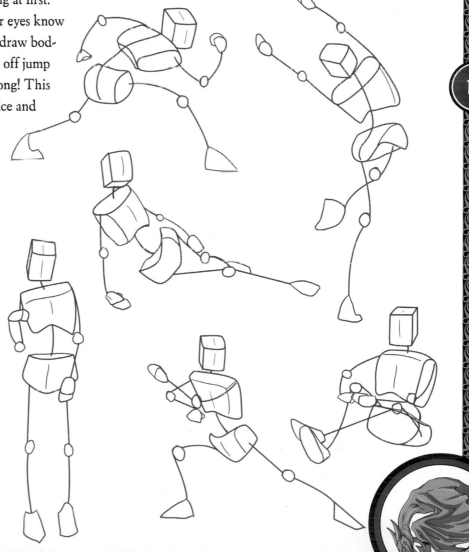

START WITH SIMPLE SHAPES

Before investing a lot of time in a pose, sketch out an extremely loose framework. Use 3-D boxes to represent the head, chest and hips to show the direction a figure is facing and the movement it's making. If your simple line-and-circle sketch isn't okay, you'll have only spent like one minute drawing out the stick and box figure. Erase that sucker and try again.

19

HUMAN BODY (FEMALE FOCUS)

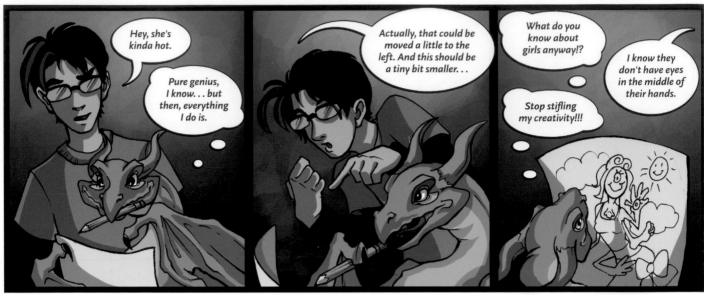

All people share similar proportions and body constructions. Despite this, both genders have slight quirks to their forms. Here are some highlights to pay special attention to.

>1<

Joints are less pronounced.

>2<

Breasts sit above the rib cage. Hips pull outward from the waist, and are generally larger and more pronounced than in males.

>3<

Muscles in legs and arms are subtle. Waist pulls in sharply.

>4<

Keep the large shadows across the major forms of the body. Muscles will have very soft shadows in comparison, if they have them at all.

HUMAN BODY (MALE FOCUS)

The male body has its own set of areas that need some subtle differentiation. Here are some things to keep in mind when drawing the male form.

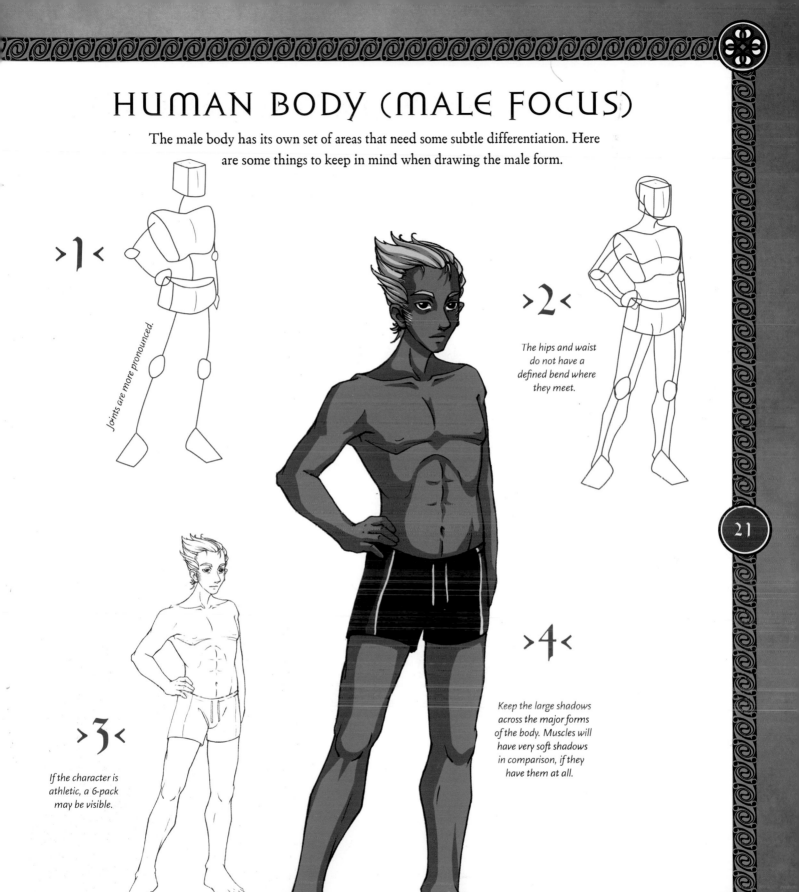

>1<

Joints are more pronounced.

>2<

The hips and waist do not have a defined bend where they meet.

>3<

If the character is athletic, a 6-pack may be visible.

>4<

Keep the large shadows across the major forms of the body. Muscles will have very soft shadows in comparison, if they have them at all.

FACIAL PROPORTIONS

Except in cases of identical twins, or, still rarer, identical fauns, all faces are different. That said, most faces follow a constant set of relative measurements. Laying out basic face shapes based on these measurements before you begin the unique features of your head will help you achieve a believable, good-looking drawing.

>1<

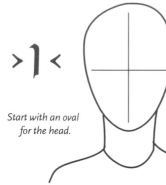

Start with an oval for the head.

Draw a horizontal line (eyeline) in the middle of the oval. Draw a vertical line down the middle.

>2<

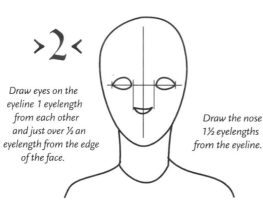

Draw eyes on the eyeline 1 eyelength from each other and just over ½ an eyelength from the edge of the face.

Draw the nose 1½ eyelengths from the eyeline.

>3<

Add the mouth 1 eyelength from the bottom of the nose.

Eyebrows sit ½ an eyelength from the top of the eyes.

Ears extend from the eyeline to the noseline.

>4<

Begin adding the quirks and features that make a character unique. Thick or thin eyebrows, a full head of hair, eye shape, lip shape, nose definition—these features will make your character an individual.

>5<

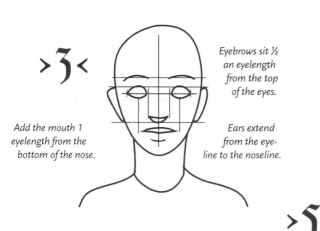

Set the eyes back into the skull with some deep shadows. Add highlights across the face where the cheekbones jut out and shadows under the nose and lips.

FACIAL EXPRESSIONS

Your character won't just be staring blankly all the time. Humans have very recognizable facial expressions to convey their moods. The majority of these expressions are conveyed through the eyebrows and the lips.

A wide, closelipped grin with eyebrows held high will make your character look content.

A wide smile with exposed teeth and eyebrows held high gives your character a playful expression. A wink adds to this.

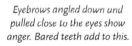

Show shock or surprise using a lot of white around the edges of the eyes.

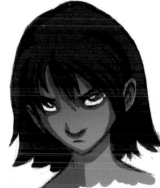

For brooding anger, angling the eyebrows will convey the emotion all on their own.

Eyebrows angled down and pulled close to the eyes show anger. Bared teeth add to this.

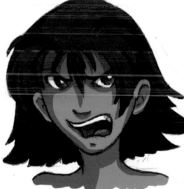

Eyebrows tilted upwards will help convey worry or sorrow. Tears help, too, but even without them this character would look distressed.

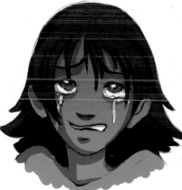

Pulling up the lip and raising an eyebrow can show confusion.

Lips pulled off to one side and eyebrows held straight or slightly quirked show boredom.

FACIAL FEATURES

The face has several key structures, which, though tiny, are important to get right so that your person looks like a person and not a monkey. Monkeys are nice and all, but I rather fear that if too many are created, they will take over. You don't want a monkey invasion, do you? Of course you do, but I'm afraid I'll have to stop you by showing you some easy ways to break down the human face. Take that, monkey horde!

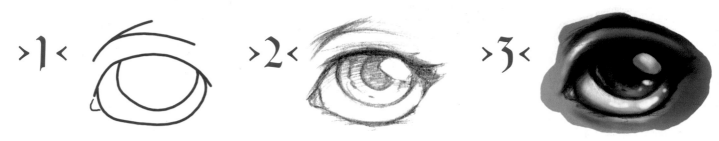

EYES

1 Eyes are perfectly round, but the eyelids create an oval shape. Leave space between the two when doing side views.

2 Irises are also circular, but are partially hidden by the eyelids unless the character is frightened. Then the entire iris is visible.

3 Since eyes sit back in the head, they are usually in shadow. Color eyes an off-white and you'll be pleased with the results!

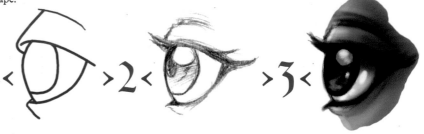

NOSES

1 There is usually a ball shape on the end of the nose. This shape is mainly used in your construction lines, and most likely will not be visible in your final linework. As you render your drawing, hints of this underlying shape will come out. Draw tear-shapes with small curves for nostrils.

2 Shading your nose will help define it. The nose sticks out from the rest of the face. Shadows will be visible on one side of the nose if light is hitting the face from the side, and typically there will be shadows underneath as well. Soften out those harsh lines.

3 The center line and tip of the nose will often have the brightest highlights. Don't make any of the highlights exceptionally bright, or the face will look greasy!

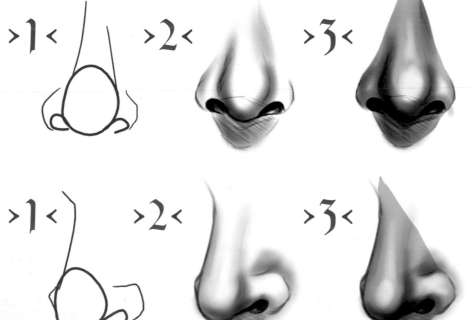

24

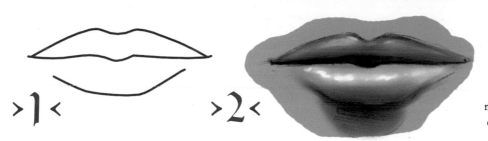

>1< >2<

Closed Mouths

Define closed mouths with one harsh line where the lips meet. Add shading underneath the lower lip to pop it out rather than drawing a harsh line around the shape.

Toothy Smiles

Make the teeth one solid shape to simplify unless those teeth are really important for your character (like a goblin). If you decide to draw the shape of each tooth, the shading on them should be extremely subtle. It's easy to end up with a dirty looking mouth.

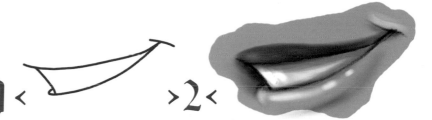

>1< >2<

Open Mouths

If you are working on a larger drawing, it's especially important to remember the details. When your character opens her mouth, you do not want a big red blob on the inside. The interior of the mouth contains very specific features—the upper and lower teeth, tongue, and even walls (you know, the inside of the cheek!). Don't overlook these small details in your rush to finish.

>1< >2<

Ears

The ear is an oval shape with many delicate shapes within that give it its complex appearance. The outer edge of the ear has a raised rim to it, and the interior has a raised piece of cartilage that echoes the shape of the ear on the inside. Shading in the innermost circle of the ear helps to set it back. The lobe of the ear is not recessed at all, so it will often be the brightest part of the ear.

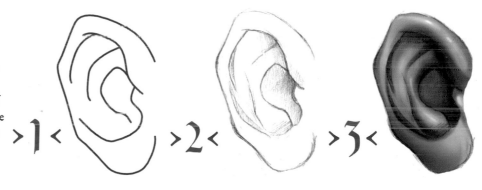

>1< >2< >3<

Ears, Three-Quarter View

When drawing the ear from a three-quarter view, you must take into account the perspective from which you are viewing it. Because the part of the ear connected to the head is closer to you than the area that sticks out farthest, it will appear to have a thick rim that gets thinner as it recedes into space.

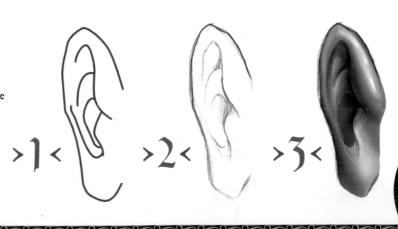

>1< >2< >3<

HAIR

Different hairstyles and effects are sometimes tricky. No matter what hair style you're drawing, do not draw each individual strand of hair; instead, start with its basic shape, then add strands for detail. Here are some different do's you might consider.

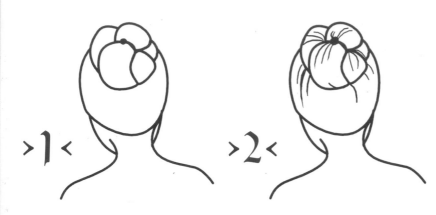

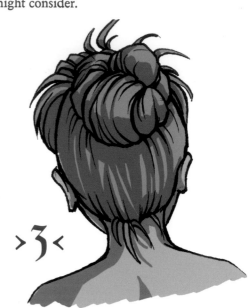

THE BUN

Draw a dot on top of your character's head. Around this dot, draw shapes that pull out, around, and back into it. This dot is the center of your bun. Add lines that follow the shape of the hair as it pulls out of and back into the center. If your character's hair is a bit messier, add some fly-away chunks. When hair is pulled into a bun, it becomes a rounder, larger object and will thus cast larger, more defined shadows. The underside of the bun will often have a shadow running along it. Don't get caught up in shading each and every strand of hair. Concentrate on large areas of shadow and highlight to get the point across.

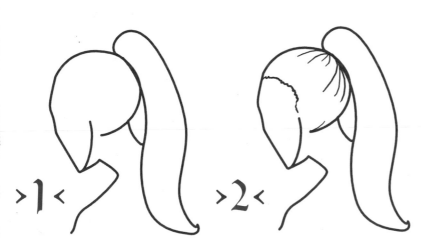

THE PONYTAIL

The ponytail can be placed high or low on the head. Add curved lines to show direction, remembering that the hair is being pulled around the skull to that center point where the ponytail is pulled tight. There will generally be a small ring of shadow along this center point as well.

26

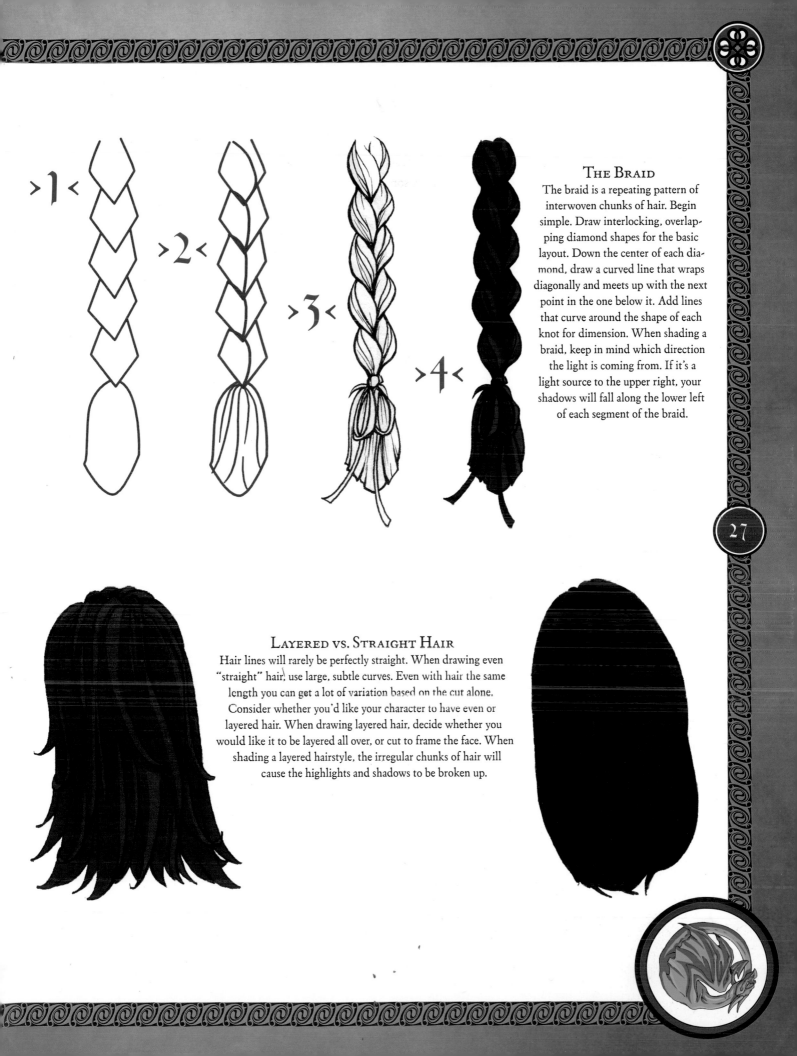

THE BRAID

The braid is a repeating pattern of interwoven chunks of hair. Begin simple. Draw interlocking, overlapping diamond shapes for the basic layout. Down the center of each diamond, draw a curved line that wraps diagonally and meets up with the next point in the one below it. Add lines that curve around the shape of each knot for dimension. When shading a braid, keep in mind which direction the light is coming from. If it's a light source to the upper right, your shadows will fall along the lower left of each segment of the braid.

LAYERED VS. STRAIGHT HAIR

Hair lines will rarely be perfectly straight. When drawing even "straight" hair, use large, subtle curves. Even with hair the same length you can get a lot of variation based on the cut alone. Consider whether you'd like your character to have even or layered hair. When drawing layered hair, decide whether you would like it to be layered all over, or cut to frame the face. When shading a layered hairstyle, the irregular chunks of hair will cause the highlights and shadows to be broken up.

HANDS

Human hands are incredibly intricate, with twenty-seven bones packed into a very tiny space. This makes them a bit of a challenge to draw. But, with some breakdown and simplification, they become something that's second nature. Remember, you have easy reference "at hand." (*groan*)

>1<

Use a box to represent the palm. Because boxes are easy to draw in perspective, this will give you a good base to work from no matter what position you would like the hand to be in.

>2<

Add the thumb. From the point where the box meets the wrist, draw 4 lines branching out in a radius, evenly spaced if seen from head on. If the box goes back into space because of perspective, take this into account. This even spacing now gives you good reference for step 3.

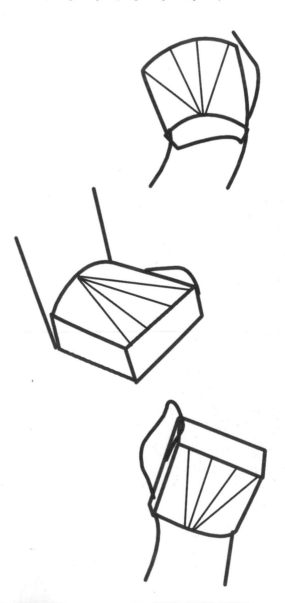

>3<

Fingers have 3 sections, but it's possible to draw them in 2. Using lines you drew as a guide, add fingers. The tips and bends of the finger will form an arc of sorts, with the middle and ring fingers longer then the pointer and little fingers.

>4<

Nail out your final linework and erase any additional construction lines. Add indications of knuckles.

>5<

Use a common light source on all areas of the hand. If the light is coming from the upper right, each and every finger will have a shadow along its lower left. The exception to this rule is if the hand is somehow directly in front of or behind a light source, in which case the light will evenly bend around it.

FEET

Feet are often overlooked, covered by shoes, boots or the surrounding foliage. Feet are just as intricate as hands, and it's important to have a believable, solid base for your character to stand on.

>1<

Simple shapes create a front half and a heel.

>2<

Feet slope downward from the ankle. There may be an indication of the ankle itself or overlap where the foot curves around.

>3<

Toes sit in an evenly spaced arc with each toe simplified into two bends—one where it meets the foot, and one inside the toe itself. The big toe is. . . well. . . bigger than the rest!

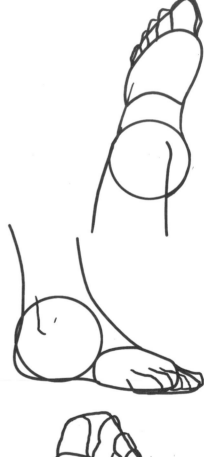

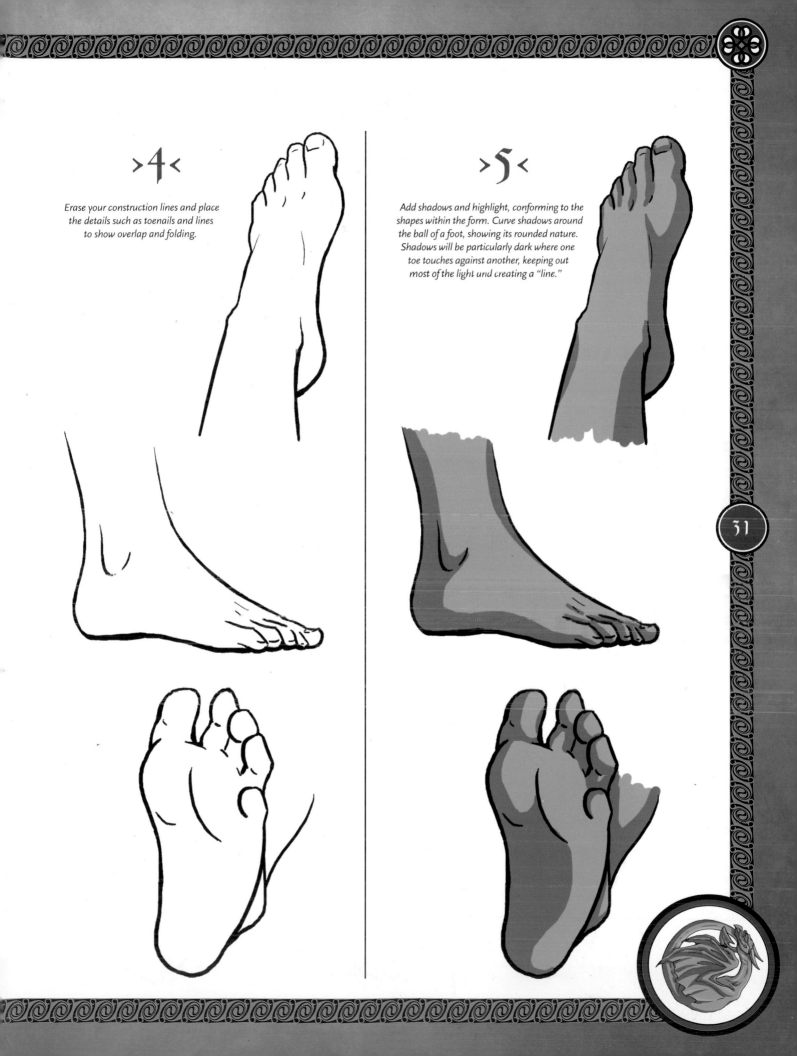

>4<

Erase your construction lines and place the details such as toenails and lines to show overlap and folding.

>5<

Add shadows and highlight, conforming to the shapes within the form. Curve shadows around the ball of a foot, showing its rounded nature. Shadows will be particularly dark where one toe touches against another, keeping out most of the light and creating a "line."

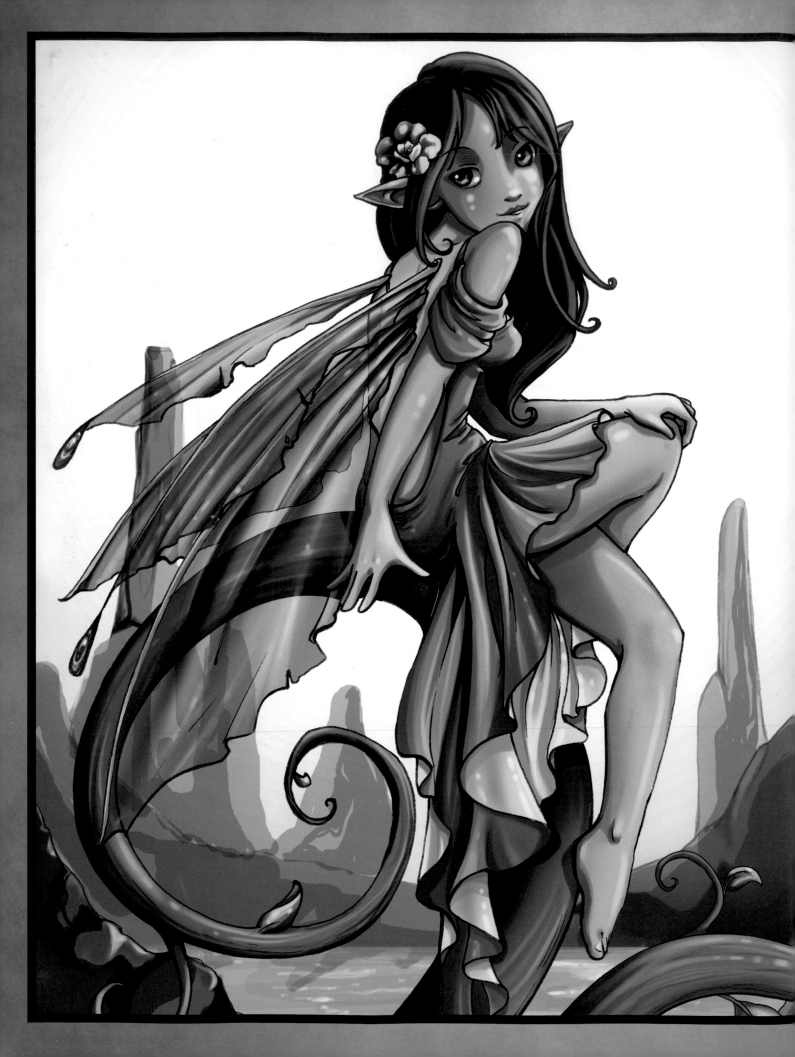

part 1

THINGS OF
FAIRY TALE

THE FAIRY KINGDOM IS A LARGE PART OF MODERN FANTASY AS WE
KNOW IT TODAY. FAIRY TALES AND FOLKLORE INFLUENCE OUR
LITERATURE, MOVIES AND GAMES. IT'S EASY TO BE INFLUENCED BY
THESE RICH TRADITIONS. SINCE FAIRIES ARE CLOSELY
TIED WITH NATURE, IT'S ALWAYS FUN TO DRAW
THEM IN EXPANSIVE NATURAL ENVIRONMENTS. BUT
REMEMBER—THIS IS FANTASY! ANYTHING'S POSSIBLE
IF YOU CAN IMAGINE IT. MAYBE YOUR CREATURES
LIVE IN AN URBAN SETTING, UNSEEN BY
THE HUMANS LIVING SO CLOSE. ARE
THERE GOBLINS HIDING IN THE
ALLEYWAYS? THERE ARE SO
MANY POSSIBILITIES.
ARE YOU READY?
LET'S DRAW!

Fairy

Fairies have always been an important part in European mythology and fairy tales. The fairies of myth and legend were both mischievous and benevolent. The fairies that we draw today may be the same, tricky creatures or a reflection of our world today. Urban fairies, anyone?

>3<

Begin filling out your fairy's head.

Connect the chest and hip boxes, creating a single, continuous shape for the body.

Give form to the stick arms and legs. The upper leg will be significantly thicker than the lower leg. The upper arm will only be a tiny bit thinner than the lower arm.

>4<

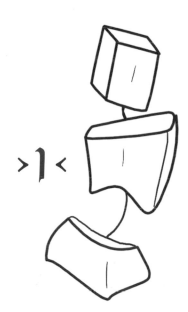

>1<

Draw 3-D box shapes for the head, chest and hips to get a feel for your fairy's pose without a huge time commitment. If you don't like it, just erase and start over.

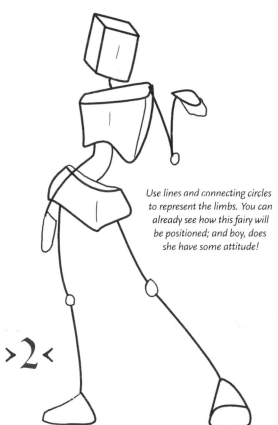

Use lines and connecting circles to represent the limbs. You can already see how this fairy will be positioned; and boy, does she have some attitude!

>2<

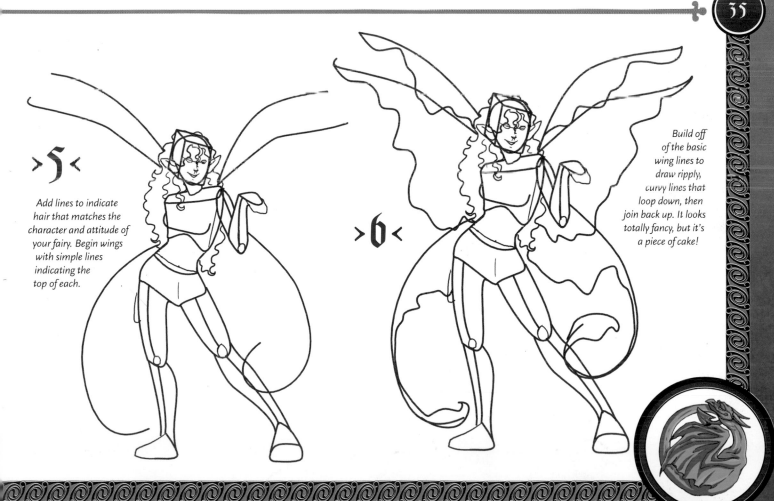

>5<

Add lines to indicate hair that matches the character and attitude of your fairy. Begin wings with simple lines indicating the top of each.

>6<

Build off of the basic wing lines to draw ripply, curvy lines that loop down, then join back up. It looks totally fancy, but it's a piece of cake!

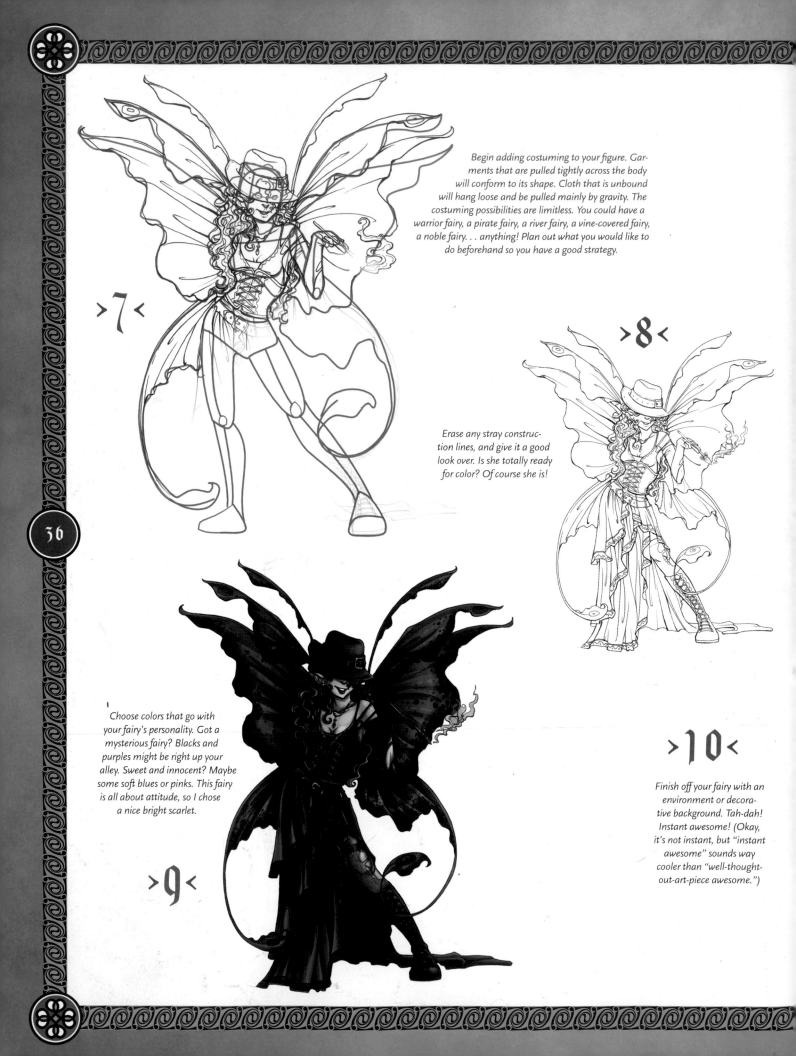

Begin adding costuming to your figure. Garments that are pulled tightly across the body will conform to its shape. Cloth that is unbound will hang loose and be pulled mainly by gravity. The costuming possibilities are limitless. You could have a warrior fairy, a pirate fairy, a river fairy, a vine-covered fairy, a noble fairy. . . anything! Plan out what you would like to do beforehand so you have a good strategy.

>7<

>8<

Erase any stray construction lines, and give it a good look over. Is she totally ready for color? Of course she is!

Choose colors that go with your fairy's personality. Got a mysterious fairy? Blacks and purples might be right up your alley. Sweet and innocent? Maybe some soft blues or pinks. This fairy is all about attitude, so I chose a nice bright scarlet.

>9<

>10<

Finish off your fairy with an environment or decorative background. Tah-dah! Instant awesome! (Okay, it's not instant, but "instant awesome" sounds way cooler than "well-thought-out-art-piece awesome.")

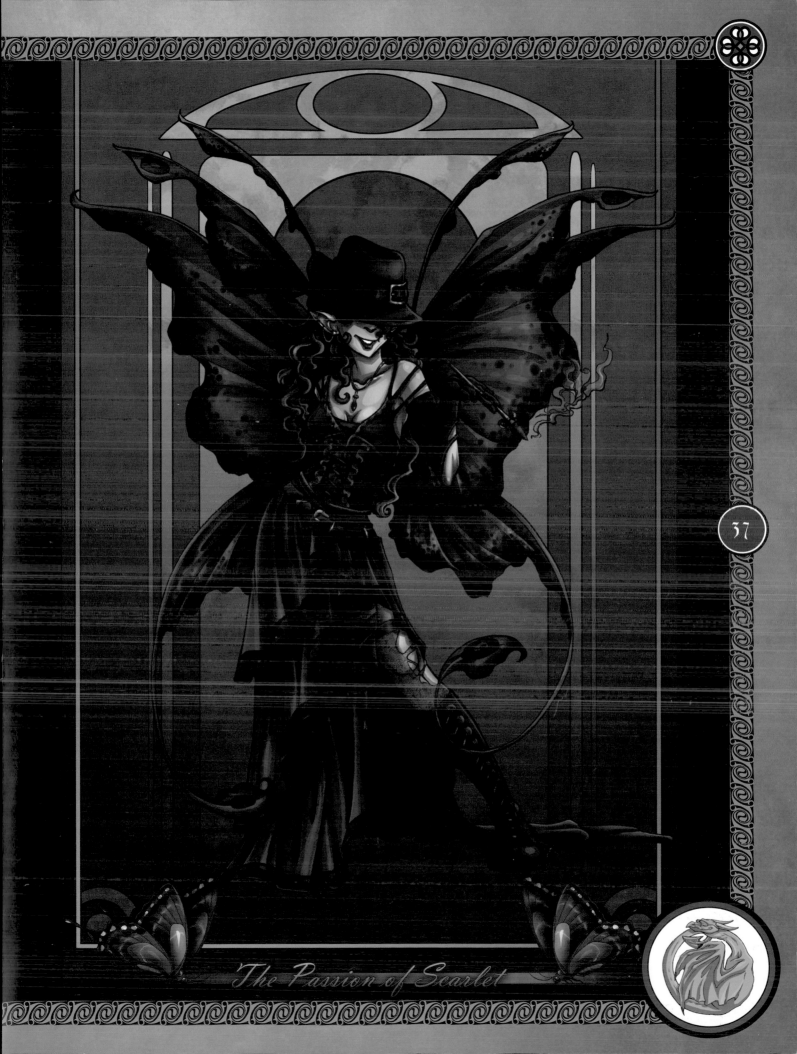

The Passion of Scarlet

FAIRY WINGS

Fairies and sprites are often held aloft by delicate insect wings. Their construction is fairly simple, but plan out the type of wing first. Butterfly, moth, dragonfly or leafy wings—each type begins with different shapes.

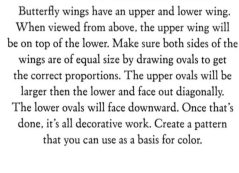

Butterfly Wings

Butterfly wings have an upper and lower wing. When viewed from above, the upper wing will be on top of the lower. Make sure both sides of the wings are of equal size by drawing ovals to get the correct proportions. The upper ovals will be larger then the lower and face out diagonally. The lower ovals will face downward. Once that's done, it's all decorative work. Create a pattern that you can use as a basis for color.

Moth Wings

Moth wings are rounder and droopier. As with butterfly wings, the upper portion overlaps the lower. Add large tails to the end of each wing. You can create the false-eye patterns seen in nature or go with a more subtle, striped effect.

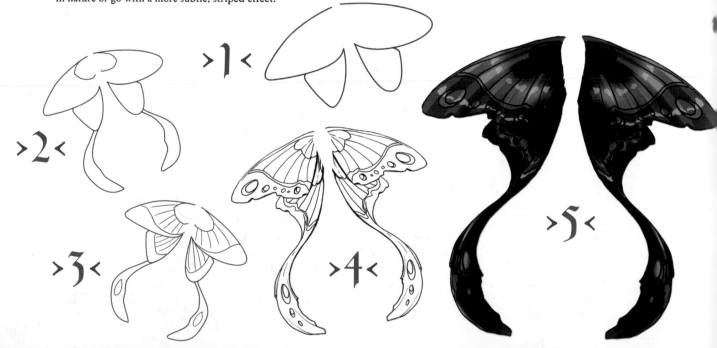

RUFFLES AND RIBBONS

The ribbon itself is a simple, flat thing. But, when it's twisted, it can create some really funky shapes. Start your ribbon with any continuous line of motion. The second set of lines that fall above and below the line of motion creates the flat, twisting shape.

THE BOW

Start your bow off simple, with triangular shapes. Add lines to suggest tightness at the knot. Create flowing ribbon that sticks out below the knot to add to the frilly effect.

THE OVERLAPPING FOLD

Folds that overlap themselves look tricky at first, but they really are just a series of vertical lines that branch off each corner of your line of motion. Draw vertical lines going up from each turning point on the left side. This will form the basic shape of the material. Draw a vertical line going up from each right turning point to show what the back of the material is doing.

THE RUFFLE

Create the bottom edges of the ruffle with a continuous line. Add vertical lines to connect each bend in this line to the top edge. Draw a second line going up behind each of the vertical lines on the overlapping bend to show the material as it bends behind itself.

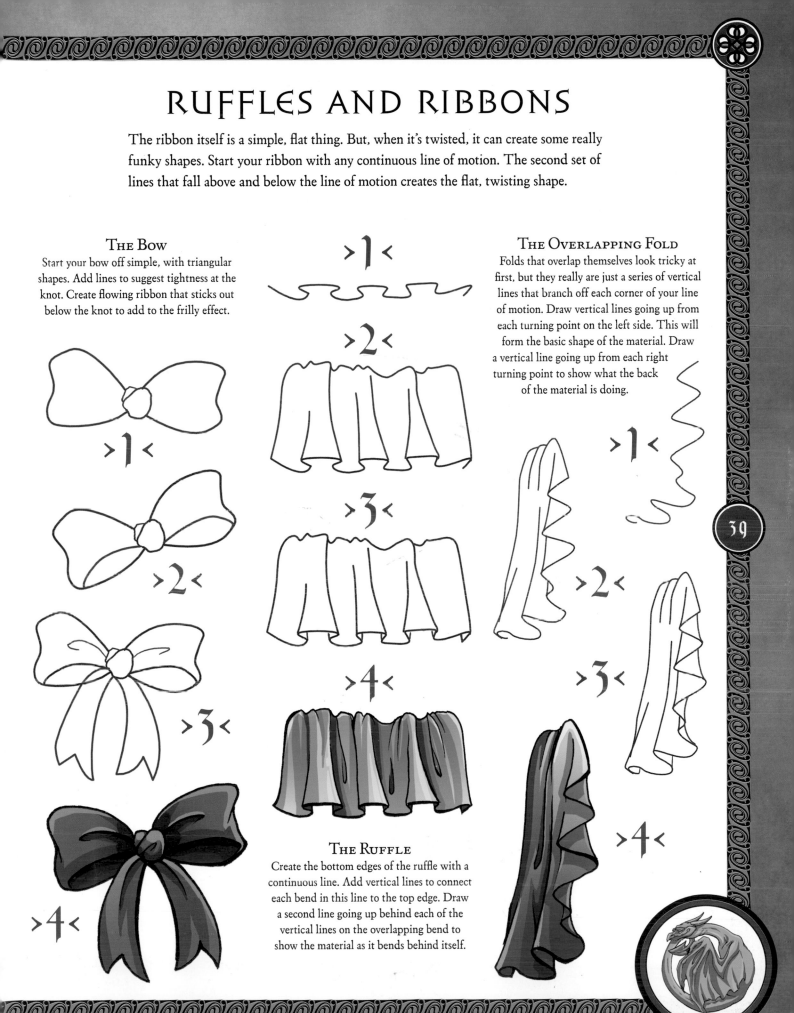

POINTY EARS

Many fantasy creatures have ears that come to a point. Start off with a standard human ear. This will give you the size and shape you'll need when you connect the ear to the head.

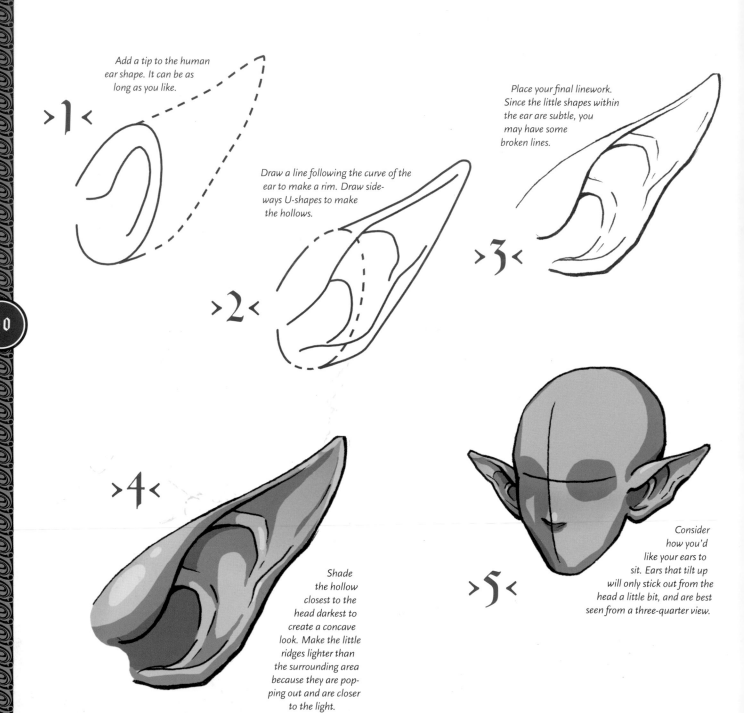

Add a tip to the human ear shape. It can be as long as you like.

>1<

Draw a line following the curve of the ear to make a rim. Draw sideways U-shapes to make the hollows.

>2<

Place your final linework. Since the little shapes within the ear are subtle, you may have some broken lines.

>3<

>4<

Shade the hollow closest to the head darkest to create a concave look. Make the little ridges lighter than the surrounding area because they are popping out and are closer to the light.

>5<

Consider how you'd like your ears to sit. Ears that tilt up will only stick out from the head a little bit, and are best seen from a three-quarter view.

Sprite

Sprites and spirits are another exciting and visually awesome part of the fairy kingdom. Sprites, like many fairy tale creatures, are mischievous and playful. You may catch a glimpse of one in the water, or hiding behind a leaf, but when you move in for a closer look, you find it's mysteriously disappeared!

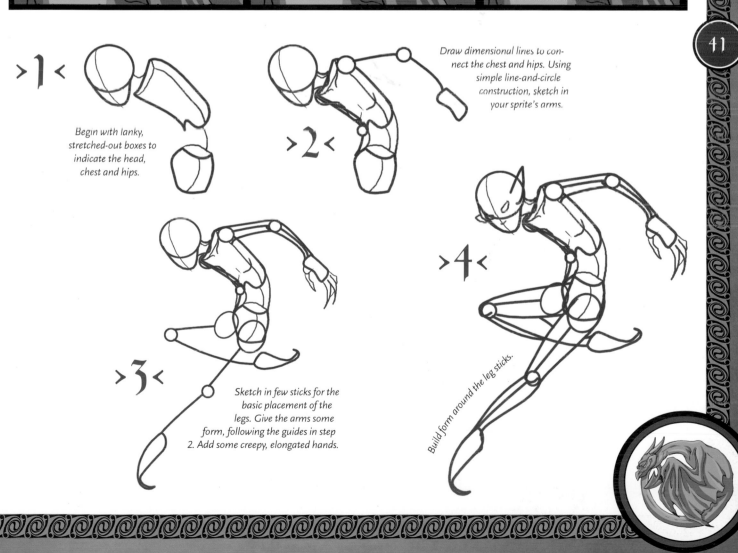

>1<

Begin with lanky, stretched-out boxes to indicate the head, chest and hips.

>2<

Draw dimensional lines to connect the chest and hips. Using simple line-and-circle construction, sketch in your sprite's arms.

>3<

Sketch in few sticks for the basic placement of the legs. Give the arms some form, following the guides in step 2. Add some creepy, elongated hands.

>4<

Build form around the leg sticks.

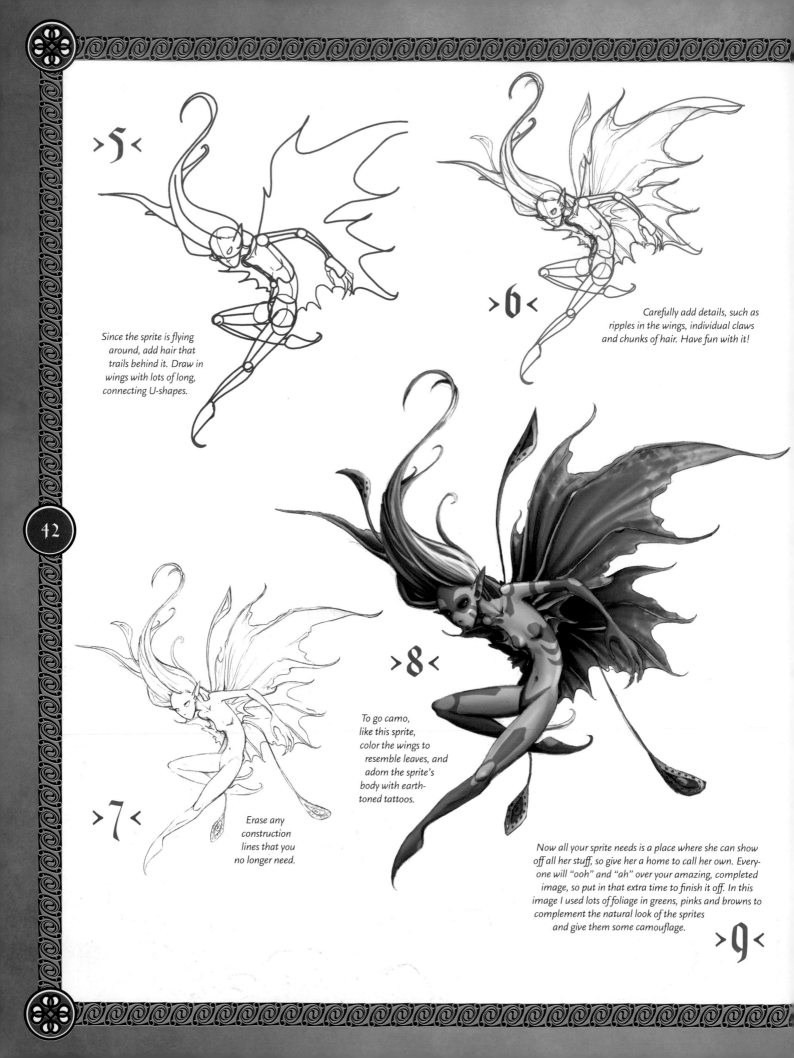

>5<

Since the sprite is flying around, add hair that trails behind it. Draw in wings with lots of long, connecting U-shapes.

>6<

Carefully add details, such as ripples in the wings, individual claws and chunks of hair. Have fun with it!

>7<

Erase any construction lines that you no longer need.

>8<

To go camo, like this sprite, color the wings to resemble leaves, and adorn the sprite's body with earth-toned tattoos.

Now all your sprite needs is a place where she can show off all her stuff, so give her a home to call her own. Everyone will "ooh" and "ah" over your amazing, completed image, so put in that extra time to finish it off. In this image I used lots of foliage in greens, pinks and browns to complement the natural look of the sprites and give them some camouflage.

>9<

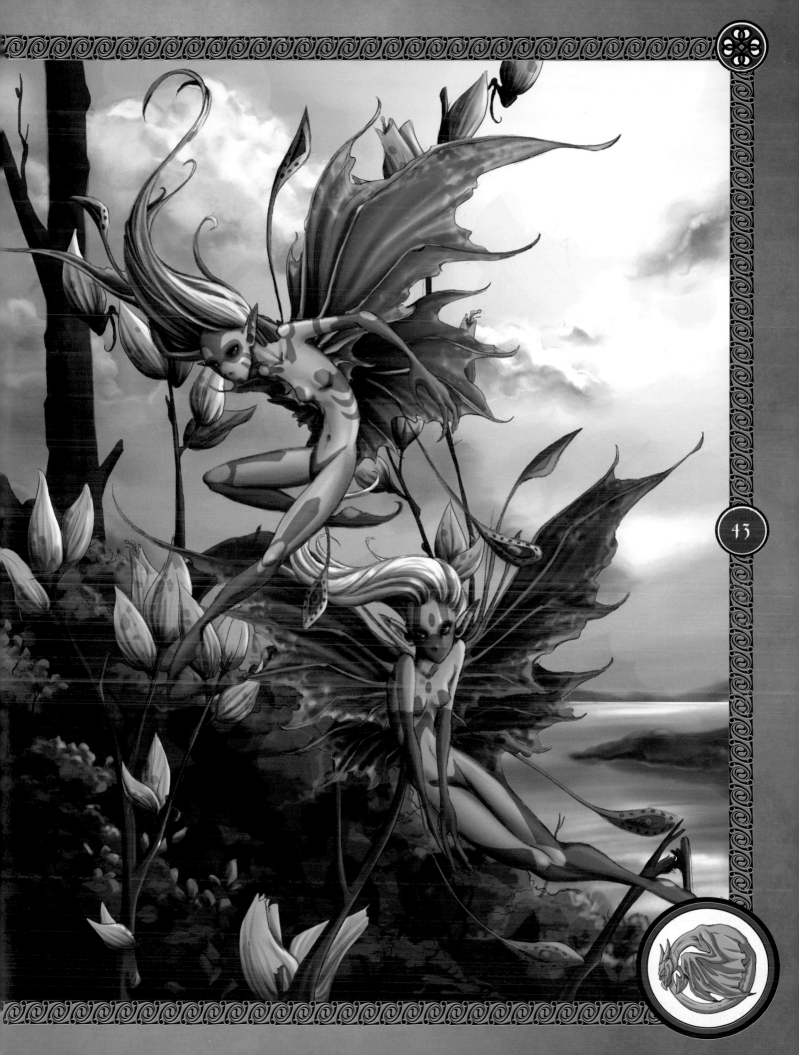

Elf

Elves have appeared in European literature for centuries, though this is probably not how you came to know them. Today, elves are mentioned less when referring to fairy tales, and more when referring to Santa, cookie bakers and rangers. The elves shown on these pages are the kind more commonly associated with modern fantasy. As such, they resemble tall, elegant people with pointed ears.

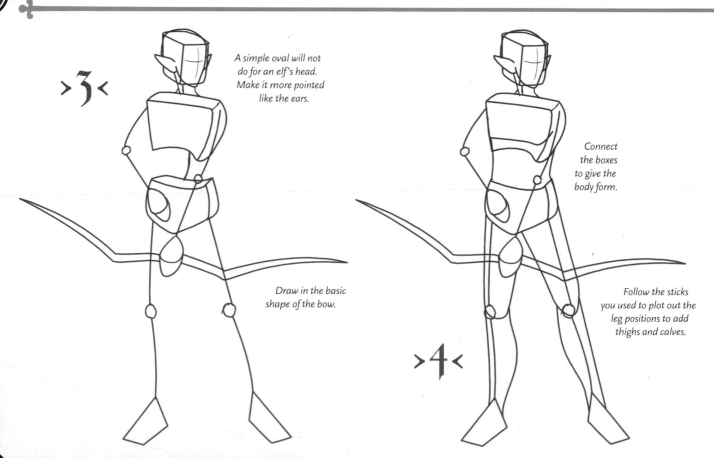

>3<

A simple oval will not do for an elf's head. Make it more pointed like the ears.

Draw in the basic shape of the bow.

Connect the boxes to give the body form.

>4<

Follow the sticks you used to plot out the leg positions to add thighs and calves.

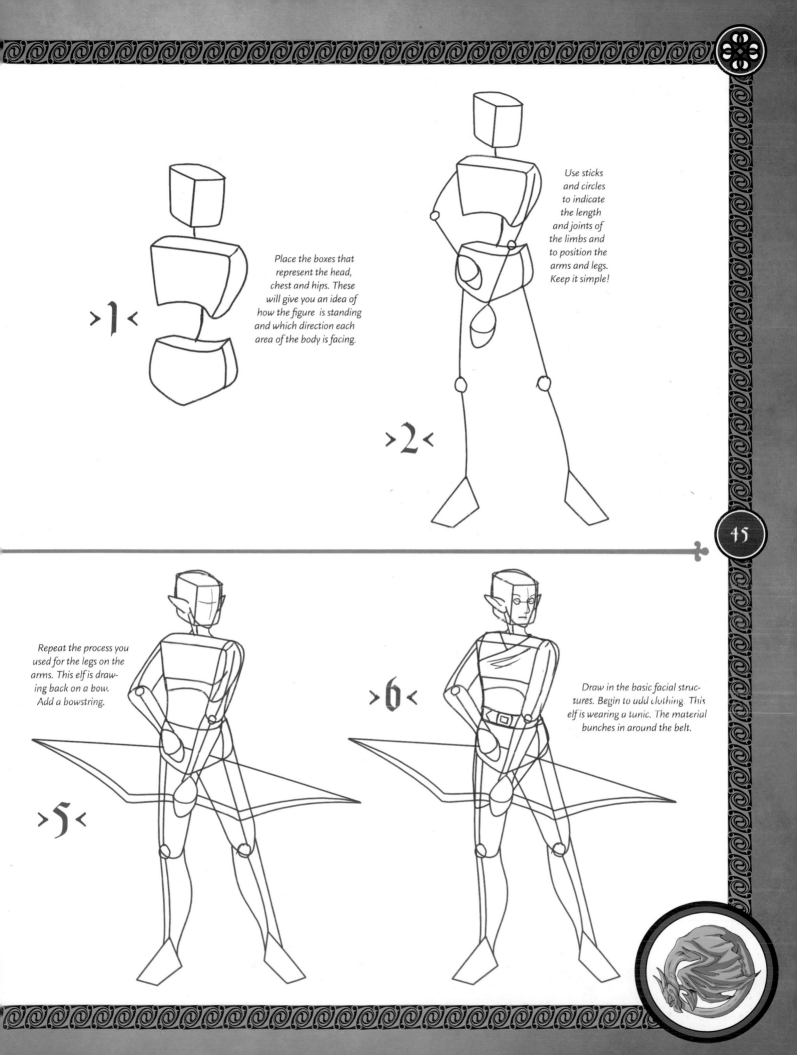

>1< Place the boxes that represent the head, chest and hips. These will give you an idea of how the figure is standing and which direction each area of the body is facing.

Use sticks and circles to indicate the length and joints of the limbs and to position the arms and legs. Keep it simple!

>2<

Repeat the process you used for the legs on the arms. This elf is drawing back on a bow. Add a bowstring.

>5<

>6< Draw in the basic facial structures. Begin to add clothing. This elf is wearing a tunic. The material bunches in around the belt.

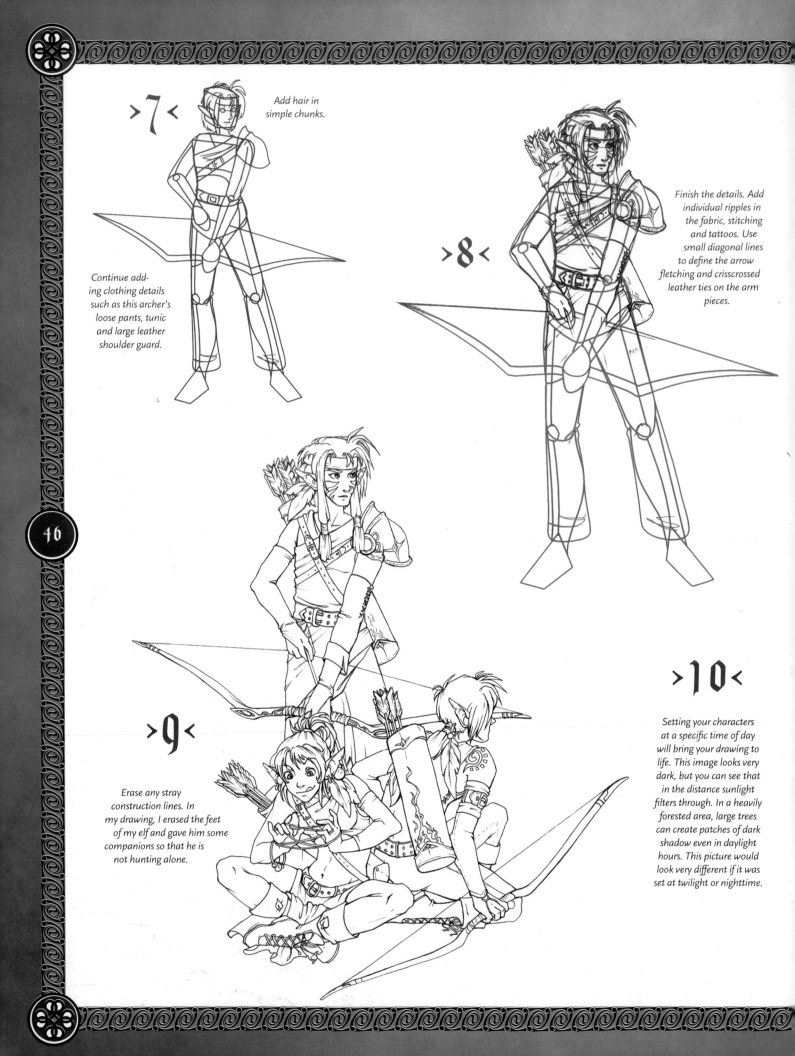

>7<

Add hair in simple chunks.

Continue adding clothing details such as this archer's loose pants, tunic and large leather shoulder guard.

>8<

Finish the details. Add individual ripples in the fabric, stitching and tattoos. Use small diagonal lines to define the arrow fletching and crisscrossed leather ties on the arm pieces.

>9<

Erase any stray construction lines. In my drawing, I erased the feet of my elf and gave him some companions so that he is not hunting alone.

>10<

Setting your characters at a specific time of day will bring your drawing to life. This image looks very dark, but you can see that in the distance sunlight filters through. In a heavily forested area, large trees can create patches of dark shadow even in daylight hours. This picture would look very different if it was set at twilight or nighttime.

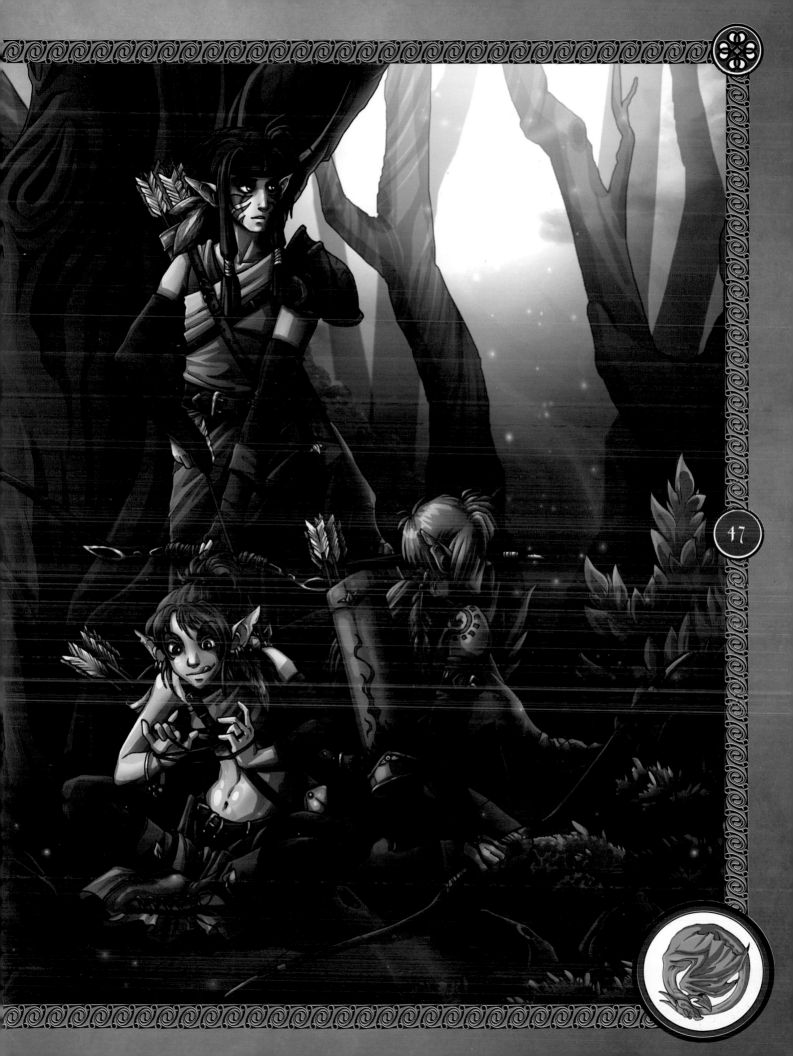

Goblin

Goblins are mischievous, sometimes wicked little fairies that enjoy playing tricks on unsuspecting people. Once you draw a goblin, watch your desk carefully. If your art supplies go missing, you'll know who to blame.

Goblins are fairy-tale creatures of the Unseelie fairy court.

They were notorious for playing pranks and tricks. People would often blame their troubles on them.

Since the idea of goblins and other fairytale creatures is preposterous, I blame all my personal woes on raccoons.

I hate those raccoons. . .

48

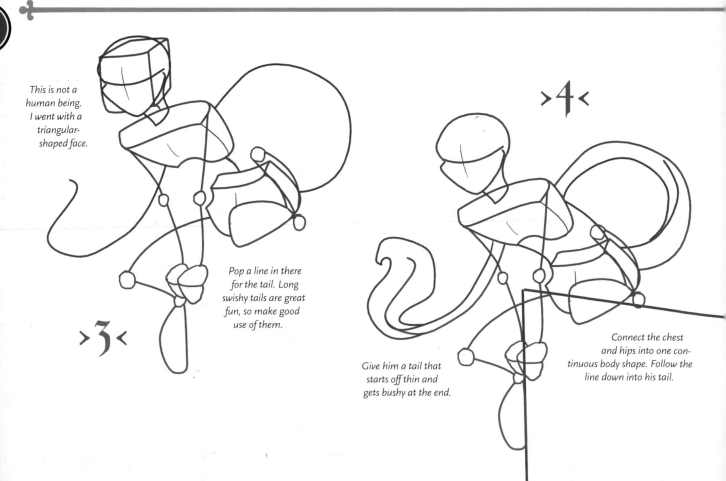

This is not a human being. I went with a triangular-shaped face.

Pop a line in there for the tail. Long swishy tails are great fun, so make good use of them.

>3<

>4<

Give him a tail that starts off thin and gets bushy at the end.

Connect the chest and hips into one continuous body shape. Follow the line down into his tail.

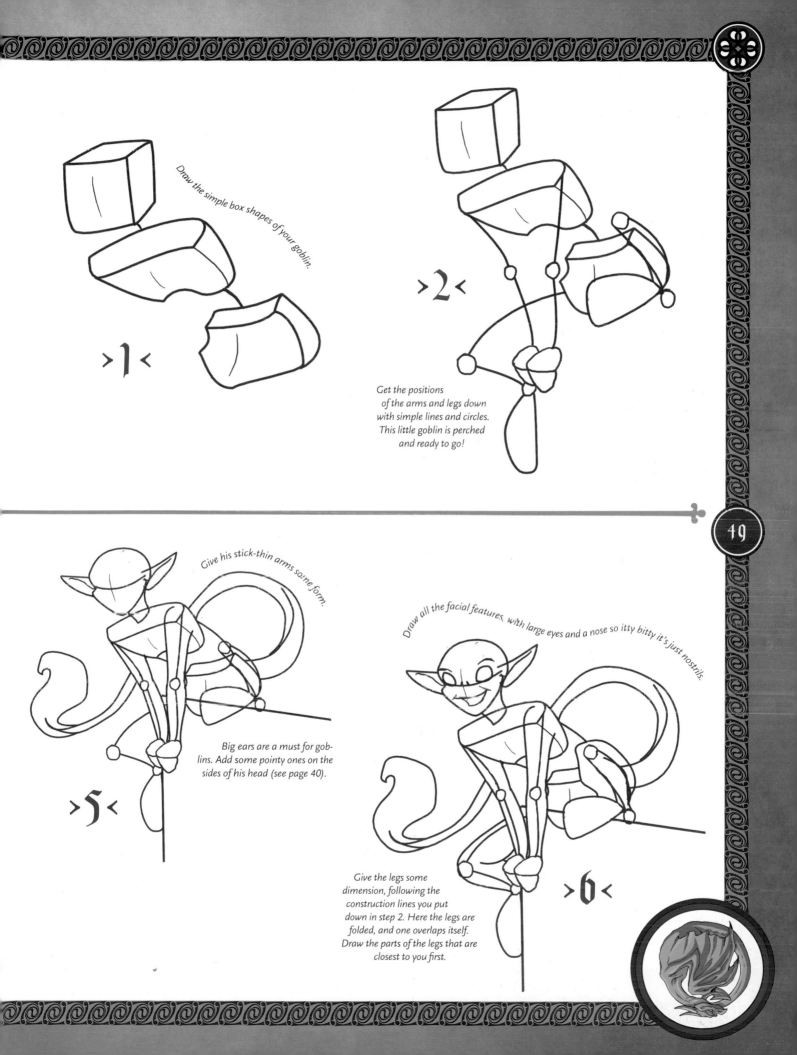

Draw the simple box shapes of your goblin.

>1<

>2<

Get the positions
of the arms and legs down
with simple lines and circles.
This little goblin is perched
and ready to go!

Give his stick-thin arms some form.

Big ears are a must for gob-
lins. Add some pointy ones on the
sides of his head (see page 40).

>5<

Draw all the facial features, with large eyes and a nose so itty bitty it's just nostrils.

Give the legs some
dimension, following the
construction lines you put
down in step 2. Here the legs are
folded, and one overlaps itself.
Draw the parts of the legs that are
closest to you first.

>6<

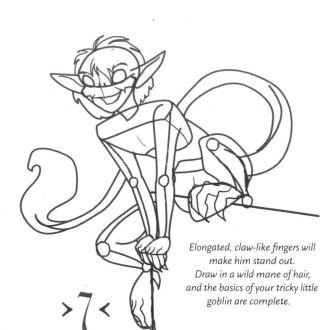

>7<

Elongated, claw-like fingers will make him stand out. Draw in a wild mane of hair, and the basics of your tricky little goblin are complete.

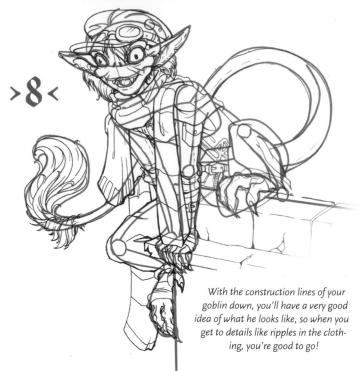

>8<

With the construction lines of your goblin down, you'll have a very good idea of what he looks like, so when you get to details like ripples in the clothing, you're good to go!

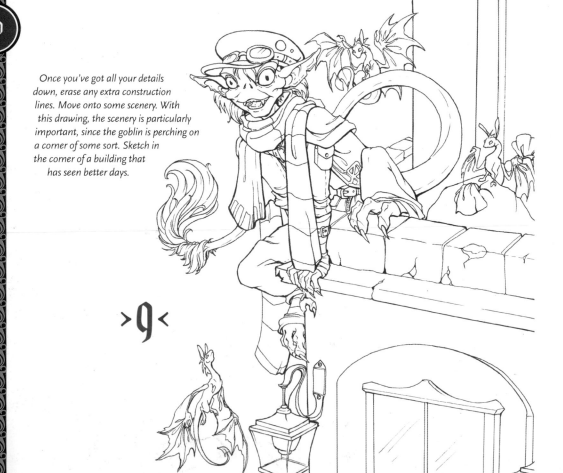

Once you've got all your details down, erase any extra construction lines. Move onto some scenery. With this drawing, the scenery is particularly important, since the goblin is perching on a corner of some sort. Sketch in the corner of a building that has seen better days.

>9<

>10<

Color your goblin any color of the rainbow. He can be as bright or as muted as you want. Maybe he's colored like his environment. This goblin is perched in a murky city, so he has muted, murky colors.

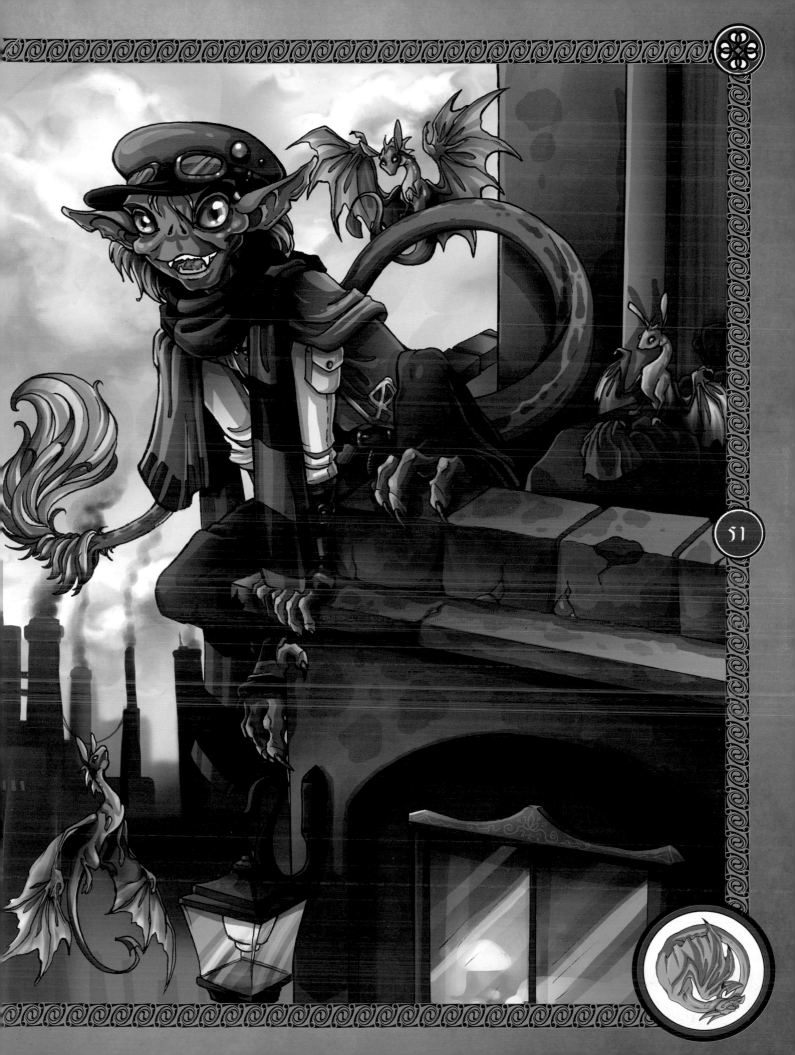

Dwarf

Dwarves have origins in Norse mythology. Most dwarves are described as being short and stocky with the males (and sometimes the females) sporting long, full beards. Dwarves are fierce, if inelegant, warriors. The stereotypical dwarf is a gruff, grumpy sort who's very set in his ways. Your dwarven character can stick to this cliché, or perhaps yours is just a big softie.

You can tell a lot of different stories with the same character—

—so before you begin—

—carefully consider what you'd like to do with them.

Draw the skull and face shape. Connect the head to the body with a very thick neck.

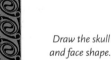

Connect the chest and hips with a line on either side, making one continuous shape.

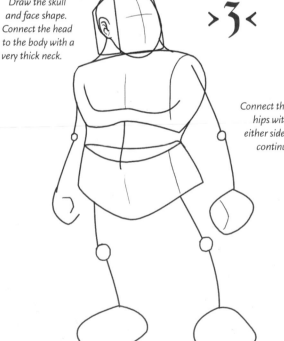

Add substance to those stick arms and legs. Remember, your dwarf's limbs will be short, but very thick.

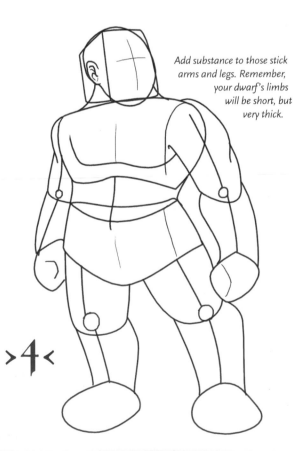

>1<

Lay down the chest, hips and head. Since dwarves are short, stocky creatures, squish everything vertically and stretch it horizontally.

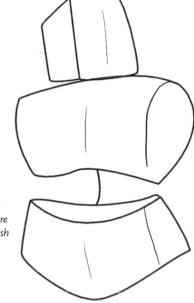

Draw in some quick sticks to indicate the arms and legs. Erase and reposition as needed until you find something you like.

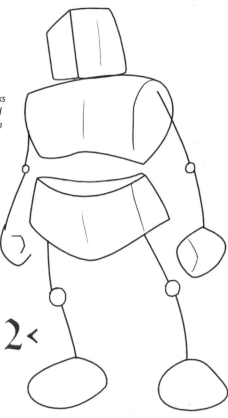

>2<

Put axes in his hands. Begin with the handles, drawing cylinders or long rectangles going back in space. Draw the blades perpendicular to the handles.

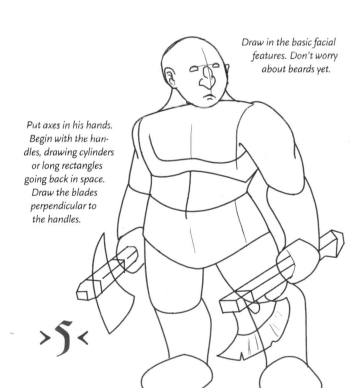

>5<

Draw in the basic facial features. Don't worry about beards yet.

>6<

Give your dwarf a beard on and around the facial features (see page 56).

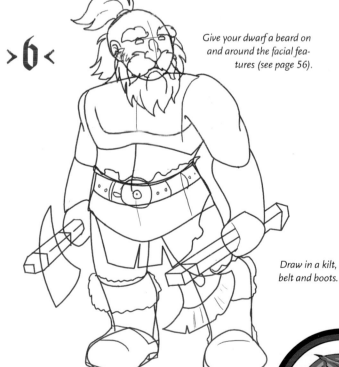

Draw in a kilt, belt and boots.

A cape, gloves and shoulder guards finish off the adventurer's look.

If you like everything you see, begin polishing. Customize belt buckles, goggles and cracks in the armor. Use your pencil in different ways to get different textures. For soft fur, try short rounded marks within and irregular edges. Use hard, perfectly smooth lines for the metallic pieces and watch the magic as the line treatments contrast.

As an added touch, line the gloves and boots with fur.

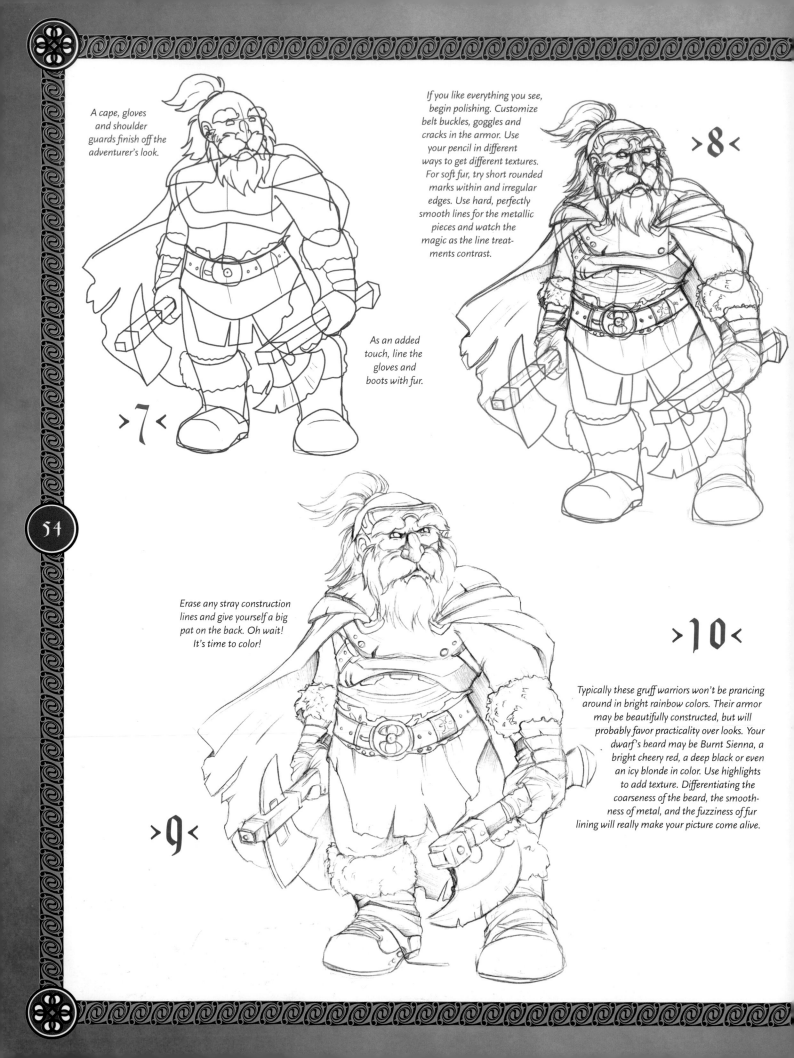

>7<

>8<

Erase any stray construction lines and give yourself a big pat on the back. Oh wait! It's time to color!

>10<

Typically these gruff warriors won't be prancing around in bright rainbow colors. Their armor may be beautifully constructed, but will probably favor practicality over looks. Your dwarf's beard may be Burnt Sienna, a bright cheery red, a deep black or even an icy blonde in color. Use highlights to add texture. Differentiating the coarseness of the beard, the smoothness of metal, and the fuzziness of fur lining will really make your picture come alive.

>9<

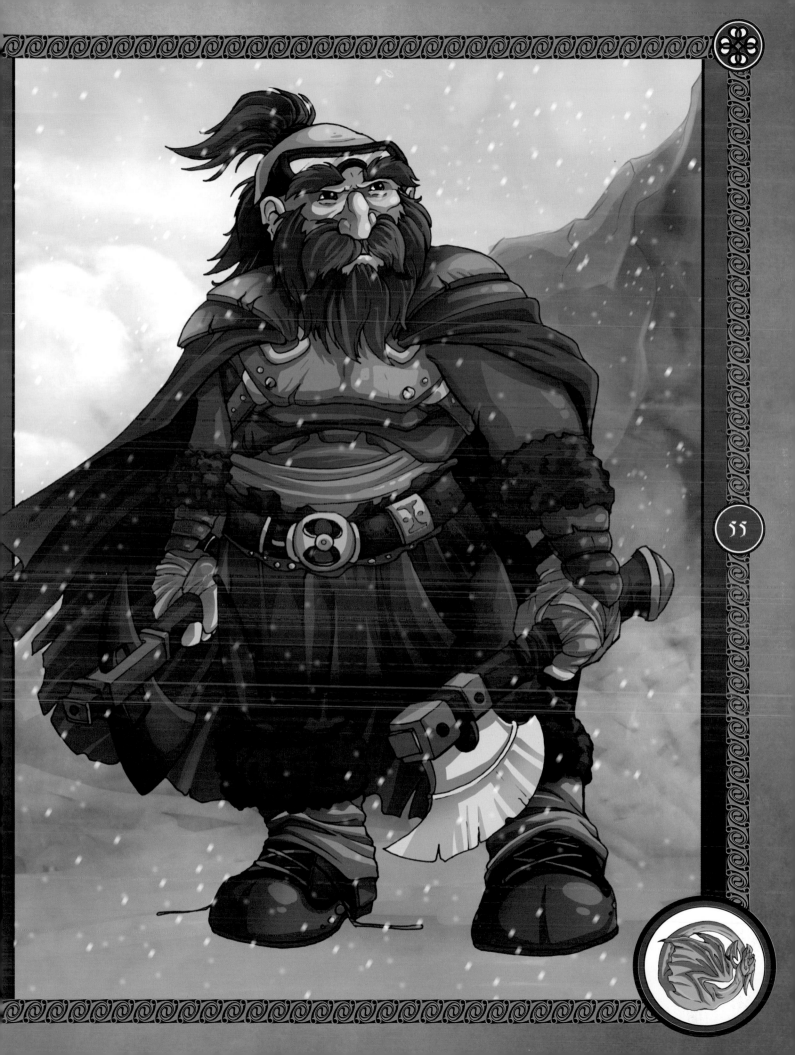

BEARDS

Beards suggest a character's personality. A close trimmed, well-cared-for beard indicates a character that is meticulous and thoughtful. Scraggly stubble shows a gruff character with little interest in grooming. Here are a few basic approaches to drawing a beard.

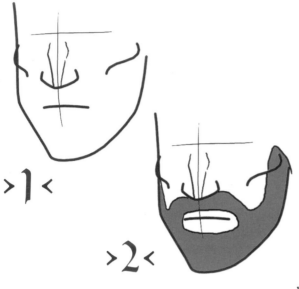

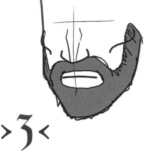

Short Beard

First, map out the places covered by hair; typically underneath the nose, around the lower jaw, and sometimes up into the hairline for thick sideburns. Shorter beards generally won't extend much past these areas, so just add texture within them.

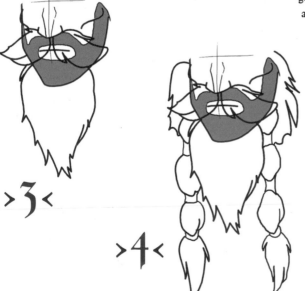

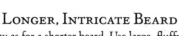

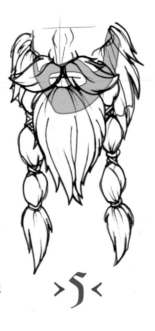

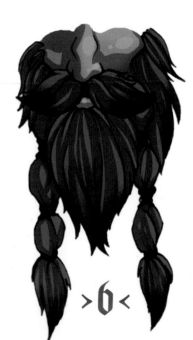

Longer, Intricate Beard

Start the same way as for a shorter beard. Use large, fluffy, intricate shapes with scraggly edges to fill out the mustache and basic beard. You can stop here or you can add braids or beads for extra interest. A simple bit of hair pulled together with a series of ties is fairly easy to achieve. Be sure to include darker shadows where the beard is tied off and pulled in tightly. And remember to include highlights in between the strips where it bulges out.

TUSKS

Tusks and fangs that grow over the lips of your character will create a feral, untamed look. These tusks are really nothing more than large teeth. They can curve up around the upper lip from the lower jaw. Or they could curve down around the lower lip from the upper jaw. For a particularly wild beastie, try tusks that don't point up or down, and instead point out.

>1<

>2<

>1<

>2<

>3<

SIMPLE TUSK
A tusk is simple cone shape, basically an overgrown canine. Easy enough.

BROKEN TUSK
If your orc, goblin or other tusked beastie has been around awhile, it may have a broken tusk. Since tusks are on the outside of the mouth, they see a little more damage than the teeth on the inside.

>3<

SETTING TUSKS IN THE MOUTH
Setting the tusk in the mouth can be tricky. Put them where you would normally place regular-sized canines. Since they are much larger, you'll need to bend the lips out and around them. These tusks are simply too big to be inside the mouth when it closes. They will come around the upper lip when the mouth is closed.

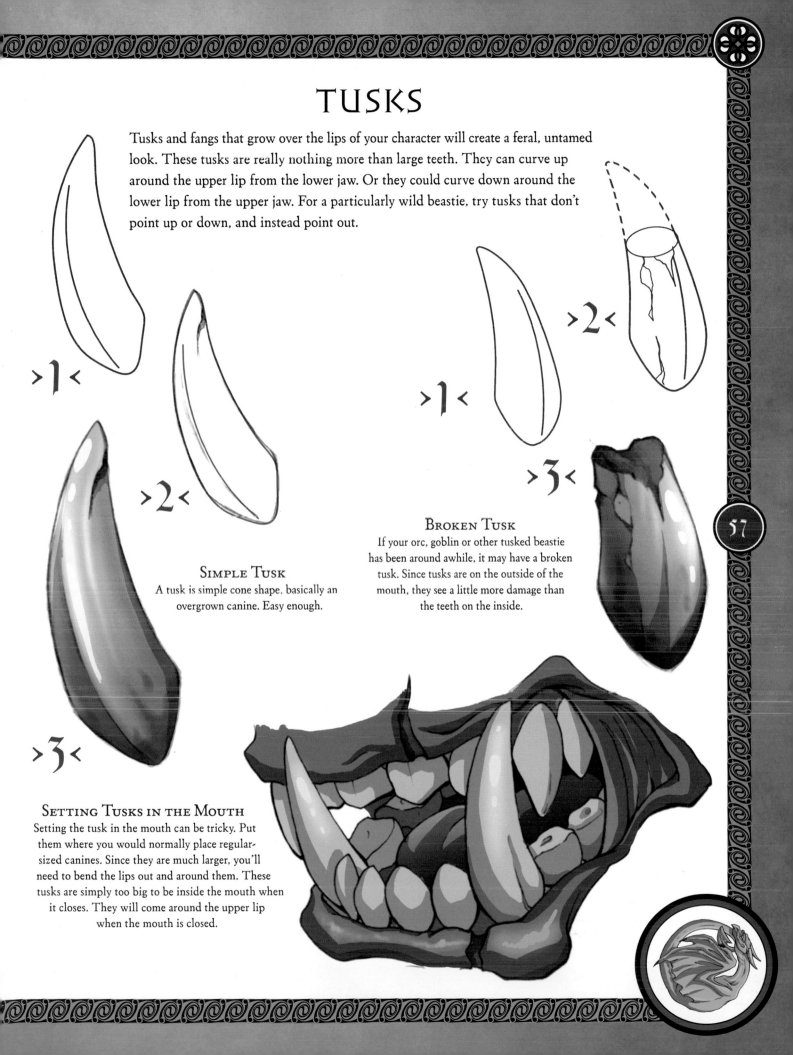

Orc

 The orc was a creature originally developed by J.R.R. Tolkien. Today, orcs have become a very common, but very important part of modern fantasy. You'll see orcs in modern fantasy novels, role-playing games and video games. They're often described as brutish, with large tusks, brows and chests. They're dirty more often than not, and come in earthy colors ranging from gray to brown to green.

Art doesn't always come easy. Some images will give you trouble over and over.

It happens to everyone. Take a break and try drawing something else. Come back to the problem image later.

Don't stress.

And don't get angry.

Because carbon just isn't that much fun to look at later on.

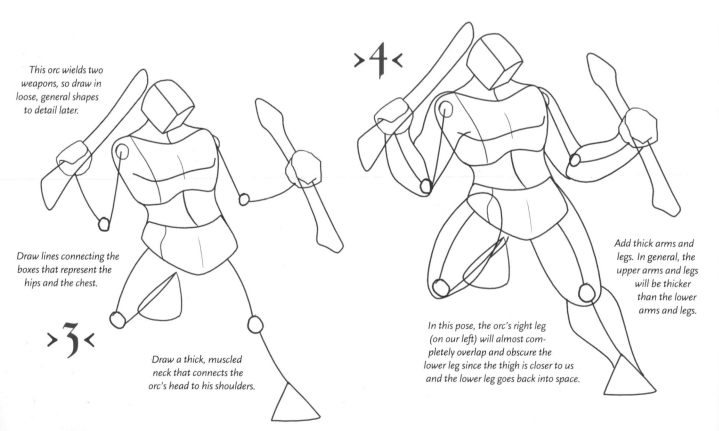

This orc wields two weapons, so draw in loose, general shapes to detail later.

Draw lines connecting the boxes that represent the hips and the chest.

> 3 <

Draw a thick, muscled neck that connects the orc's head to his shoulders.

> 4 <

Add thick arms and legs. In general, the upper arms and legs will be thicker than the lower arms and legs.

In this pose, the orc's right leg (on our left) will almost completely overlap and obscure the lower leg since the thigh is closer to us and the lower leg goes back into space.

>1<

Start off with the boxes for the head, chest and hips.

Place your orc's arms and legs. This beast is holding his arms out with one leg propped up on a stone.

Even though the thigh will overlap the lower leg on the bent leg, use guidelines to make sure that you've got the placement how you want it.

>2<

Add a pronounced bicep on each shoulder.

>5<

Give him a 6-pack and some pectoral definition.

Giving your orc defined muscles will go a long way toward making the drawing engaging.

Orcs can wear anything from barbaric animal hides to heavy plate armor. Look for tips on page 39 as you add this orc's kilt.

>6<

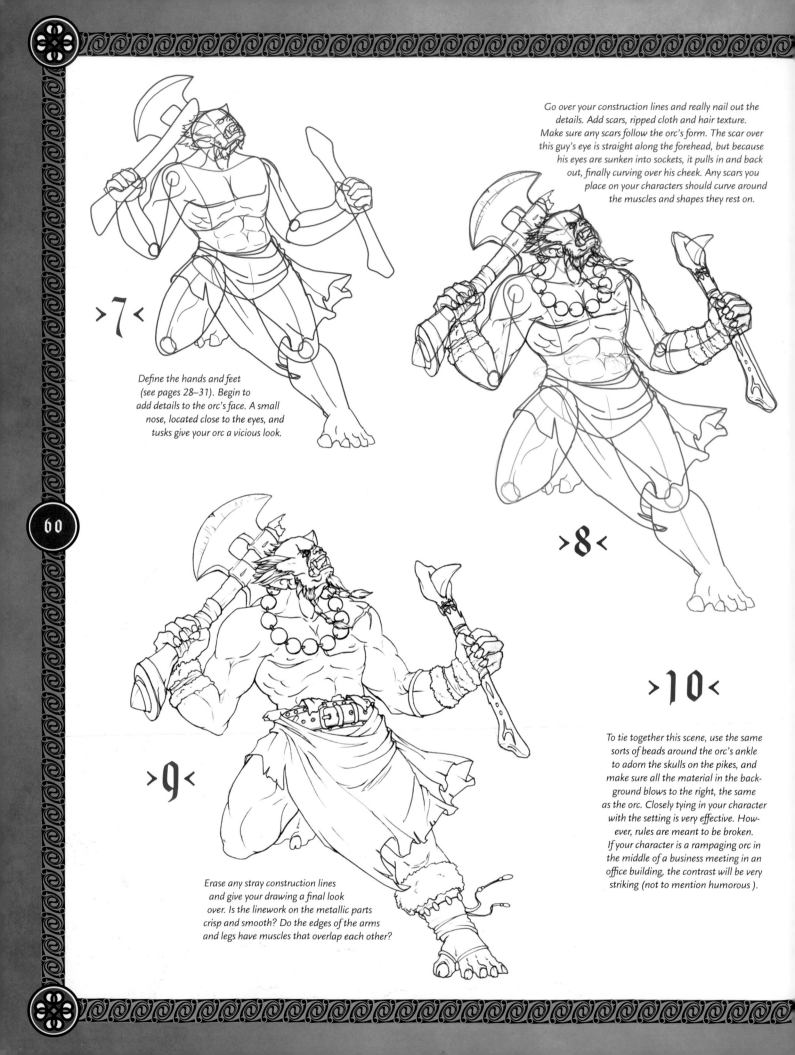

>7<

Define the hands and feet (see pages 28–31). Begin to add details to the orc's face. A small nose, located close to the eyes, and tusks give your orc a vicious look.

Go over your construction lines and really nail out the details. Add scars, ripped cloth and hair texture. Make sure any scars follow the orc's form. The scar over this guy's eye is straight along the forehead, but because his eyes are sunken into sockets, it pulls in and back out, finally curving over his cheek. Any scars you place on your characters should curve around the muscles and shapes they rest on.

>8<

>9<

Erase any stray construction lines and give your drawing a final look over. Is the linework on the metallic parts crisp and smooth? Do the edges of the arms and legs have muscles that overlap each other?

>10<

To tie together this scene, use the same sorts of beads around the orc's ankle to adorn the skulls on the pikes, and make sure all the material in the background blows to the right, the same as the orc. Closely tying in your character with the setting is very effective. However, rules are meant to be broken. If your character is a rampaging orc in the middle of a business meeting in an office building, the contrast will be very striking (not to mention humorous).

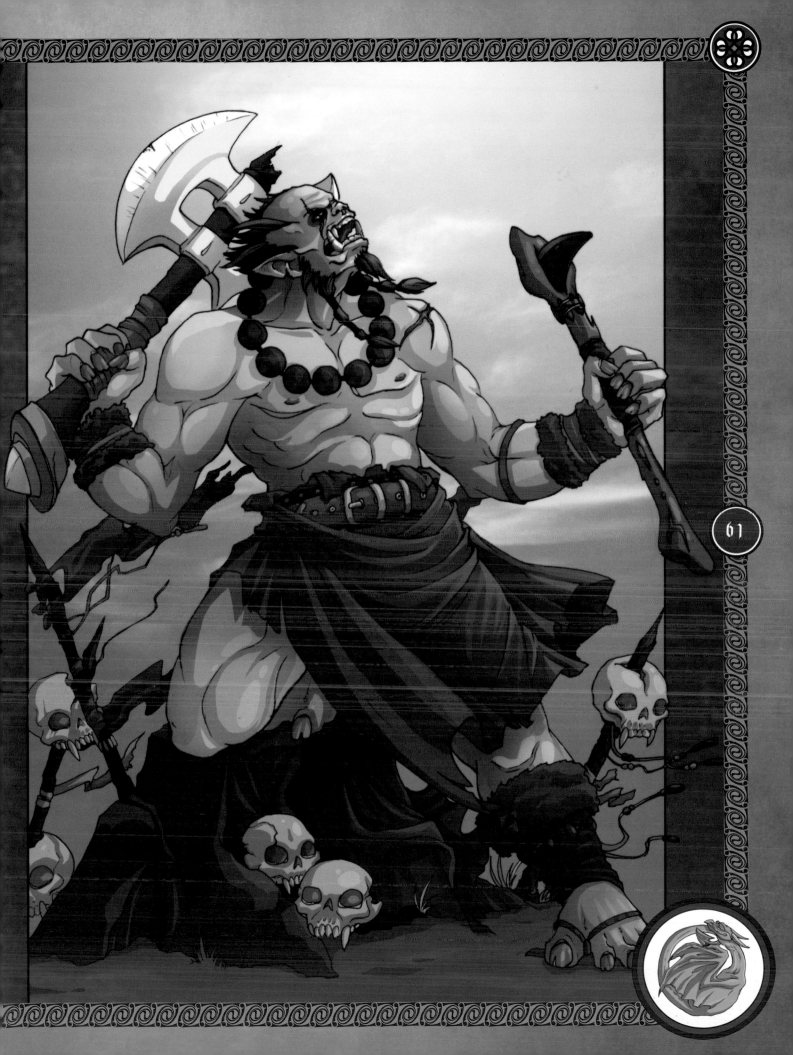

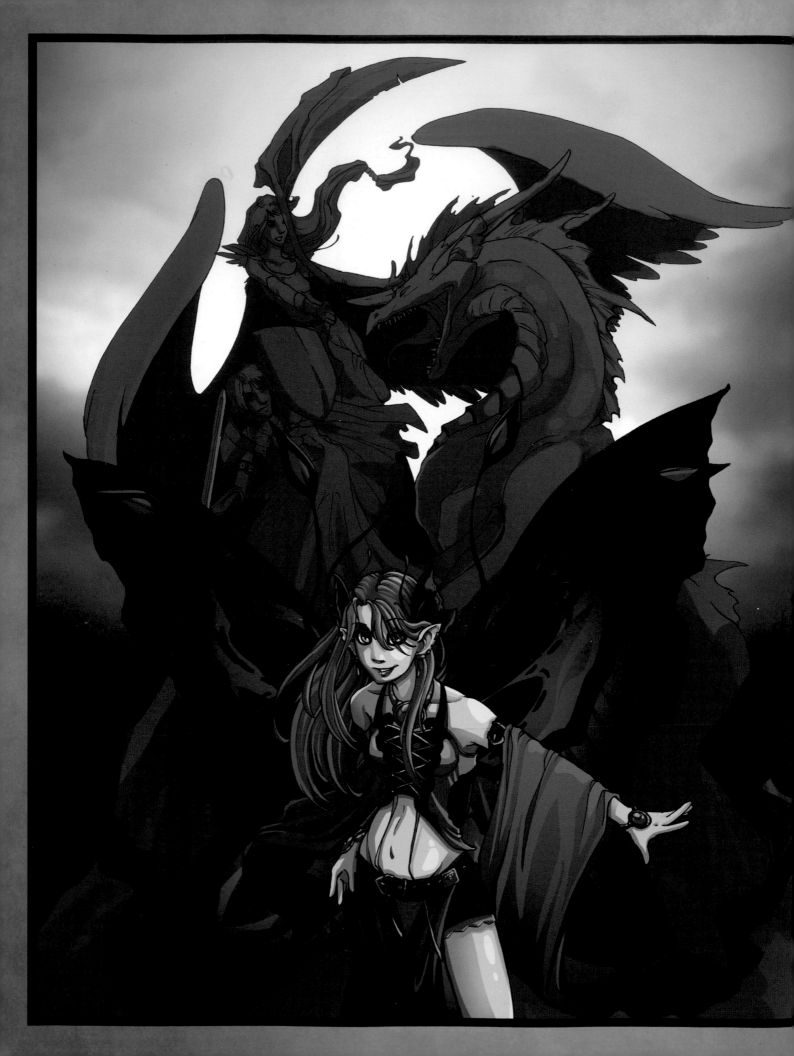

part 2

THINGS OF LEGEND

Myths and legends are epic tales mingled with histories full of exciting creatures, and drawing on these legends is a great way to fill out your fantasy universe. You can stick very closely to a myth or use your own interpretations. The story of the minotaur and the labyrinth is a well-known Greek myth, but what if you set the minotaur as a guard in a palace? Or you can use modern settings. How about a siren that lives at Sea World? Considering these possibilities puts you on the path to using myths and legends in your own fantasy world!

Mermaid

Merfolk are a sea-dwelling fantasy race. Their upper bodies closely resemble that of humans, while their lower halves are more fishlike. And, of course, they have the ability to breathe underwater. In Greek mythology, some variations of sirens were described as being very mermaidlike. (Though the majority of siren description is that of a bird, lion and woman combined.) Like the siren though, mermaids do have a beautiful song.

So yeah, mermaids.

They live underwater. Swim with fish, sing in children's musicals. That's fine and dandy, but being underwater means that some things will be drawn differently.

So when you draw them their hair will float around them, as you can see in diagram A—

Hey! Where is Diagram A!? And B—And C!?

Minion, have you seen my diagrams!?

Yes—I mean—no. No.

I love you best, Miss Diagram B. . .

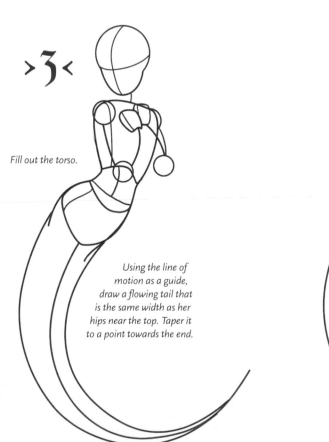

> 3 <

Fill out the torso.

Using the line of motion as a guide, draw a flowing tail that is the same width as her hips near the top. Taper it to a point towards the end.

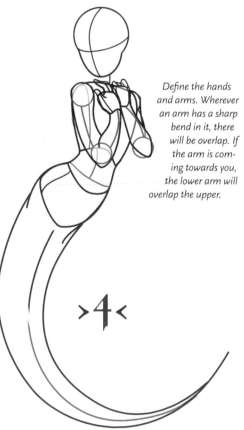

Define the hands and arms. Wherever an arm has a sharp bend in it, there will be overlap. If the arm is coming towards you, the lower arm will overlap the upper.

> 4 <

Place shapes to indicate the head, chest and hips.

Draw an extended line of motion so that you will have a guide to follow for your mermaid's tail.

>1<

>2<

Sketch out the general positioning for the arms. A simple line and ball joint arm is enough. If you decide that you are unhappy with the way the arms are positioned, simply erase them.

Lay down the bare bones of a face within the head shape. Keep in mind the proportions discussed on page 22.

>5<

>6<

You can simply put a fin (see page 68) at the end of the tail and call it done, or, you can go a little crazy. Perhaps a fin running down her back would be neat? How about a pair of frills running down either side of her tail? Fins on the shoulder blades?

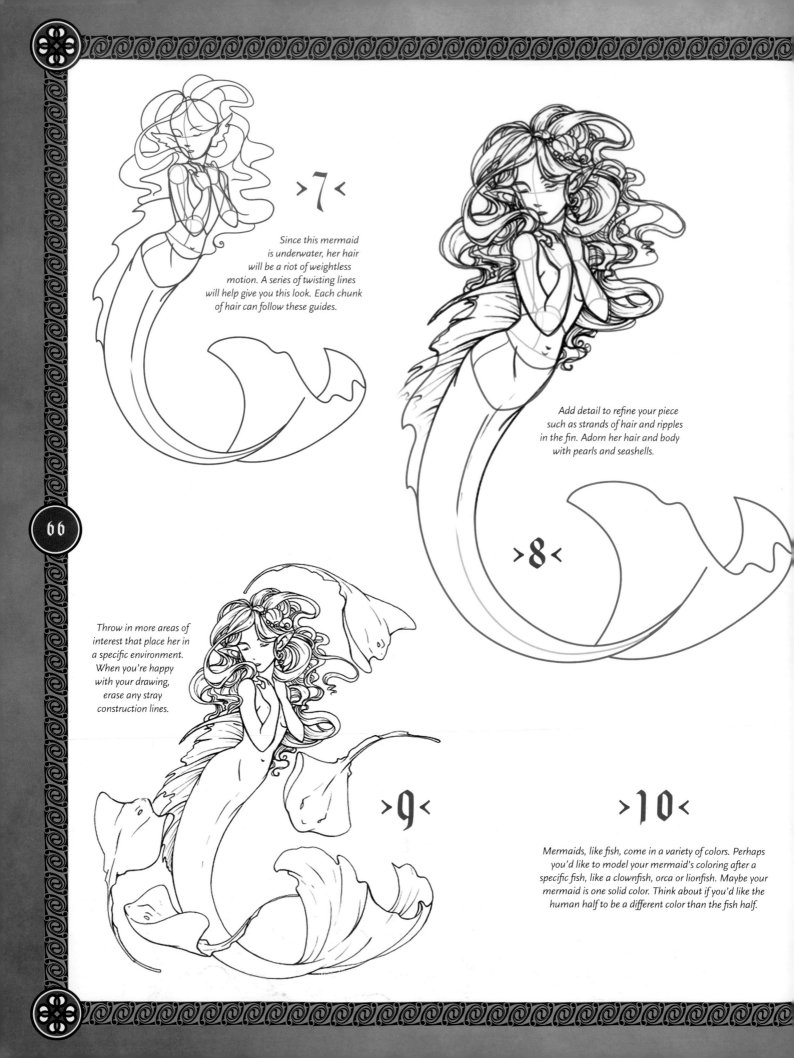

>7<

Since this mermaid is underwater, her hair will be a riot of weightless motion. A series of twisting lines will help give you this look. Each chunk of hair can follow these guides.

Add detail to refine your piece such as strands of hair and ripples in the fin. Adorn her hair and body with pearls and seashells.

>8<

Throw in more areas of interest that place her in a specific environment. When you're happy with your drawing, erase any stray construction lines.

>9<

>10<

Mermaids, like fish, come in a variety of colors. Perhaps you'd like to model your mermaid's coloring after a specific fish, like a clownfish, orca or lionfish. Maybe your mermaid is one solid color. Think about if you'd like the human half to be a different color than the fish half.

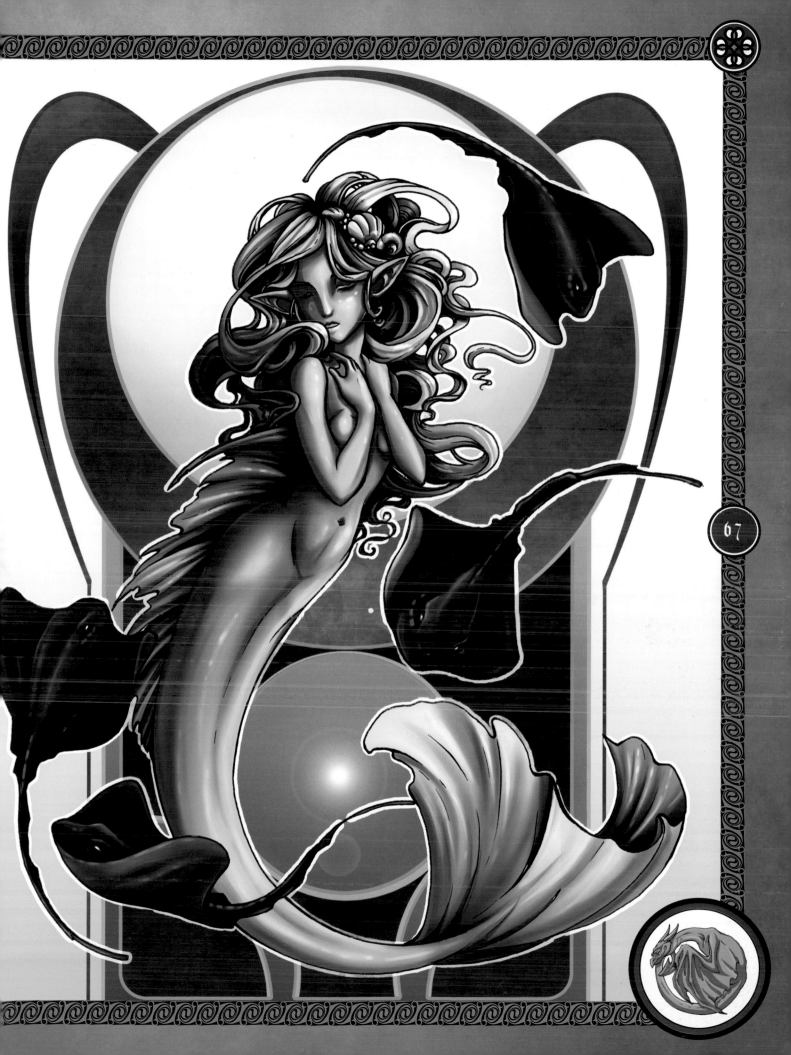

FINS

The main fin of your mermaid or sea creature is a very important feature. There are many ways to tackle this part of your character. Here are just a few ideas.

THE FRILLED FIN
This elegant fin is perfect for a wispy mermaid.

THE DOLPHIN FIN
The sweet and simple way to end your mermaid's tail.

THE BRANCHED FIN
An uncommon, yet exciting, variation.

Draw a ripply line across the bottom of the fin.

Draw two triangular shapes that face out from the taper of the tail.

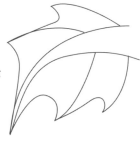

Draw lines coming out from the tail and connect them with U-shapes.

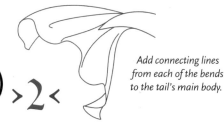

Add connecting lines from each of the bends to the tail's main body.

Give the tail a little bit of thickness by drawing a second line along the edge of it.

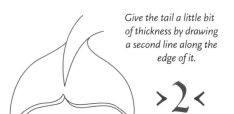

Give the fin a second line to add thickness. Add a hooked line in the middle of the membrane so it looks loose and flexible.

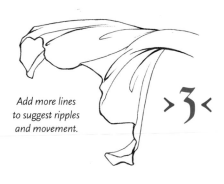

Add more lines to suggest ripples and movement.

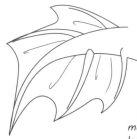

Thicker lines along the bottom edge give the fin form. Soften the upper line on the bottom edge so it's not so harsh.

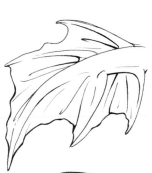

Add more lines from each of the bends to the tail's main body, suggesting movement.

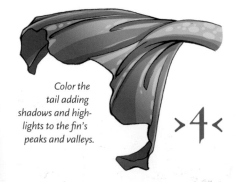

Color the tail adding shadows and highlights to the fin's peaks and valleys.

Color the tail, adding shadows and highlights to suggest a smooth, sleek surface.

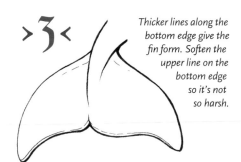

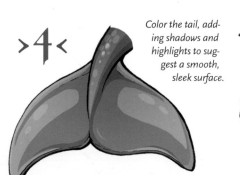

Add shadows and highlights as you color the tail to showcase its frills.

HOOVES

Many fantasy races don't have traditional feet that can be covered up in boots or shoes. Many, such as centaurs and fauns, have hooves. Here are two different types of hooves. Feel free to add your own variations.

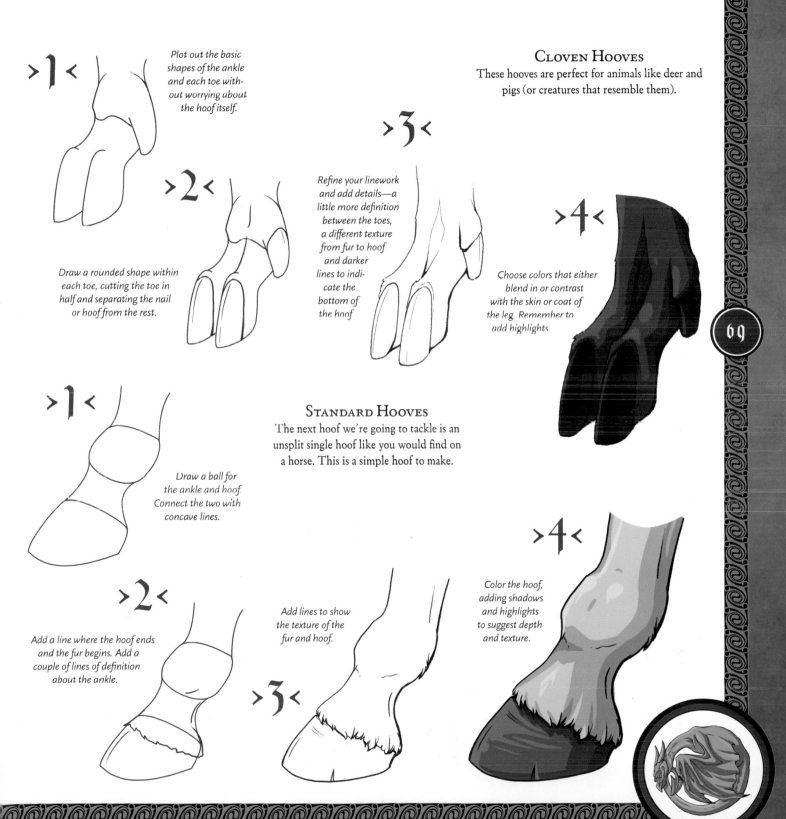

>1<

Plot out the basic shapes of the ankle and each toe without worrying about the hoof itself.

>2<

Draw a rounded shape within each toe, cutting the toe in half and separating the nail or hoof from the rest.

>3<

Refine your linework and add details—a little more definition between the toes, a different texture from fur to hoof and darker lines to indicate the bottom of the hoof.

Cloven Hooves

These hooves are perfect for animals like deer and pigs (or creatures that resemble them).

>4<

Choose colors that either blend in or contrast with the skin or coat of the leg. Remember to add highlights.

>1<

Draw a ball for the ankle and hoof. Connect the two with concave lines.

Standard Hooves

The next hoof we're going to tackle is an unsplit single hoof like you would find on a horse. This is a simple hoof to make.

>2<

Add a line where the hoof ends and the fur begins. Add a couple of lines of definition about the ankle.

Add lines to show the texture of the fur and hoof.

>3<

>4<

Color the hoof, adding shadows and highlights to suggest depth and texture.

Centaur

Half man, half horse, in ancient Greek mythology, centaurs were depicted as drunken and rowdy creatures. They were also known for carrying off young maidens. Recent fantasy has taken a different view of centaurs, giving them a more noble character and rational outlook.

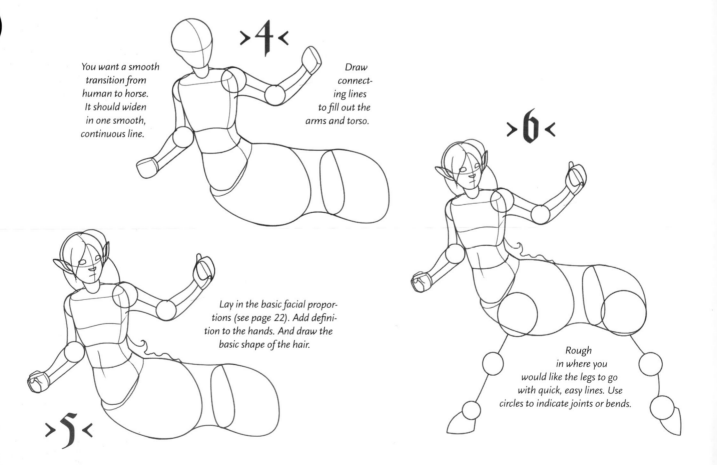

You want a smooth transition from human to horse. It should widen in one smooth, continuous line.

Draw connecting lines to fill out the arms and torso.

>4<

>6<

Lay in the basic facial proportions (see page 22). Add definition to the hands. And draw the basic shape of the hair.

>5<

Rough in where you would like the legs to go with quick, easy lines. Use circles to indicate joints or bends.

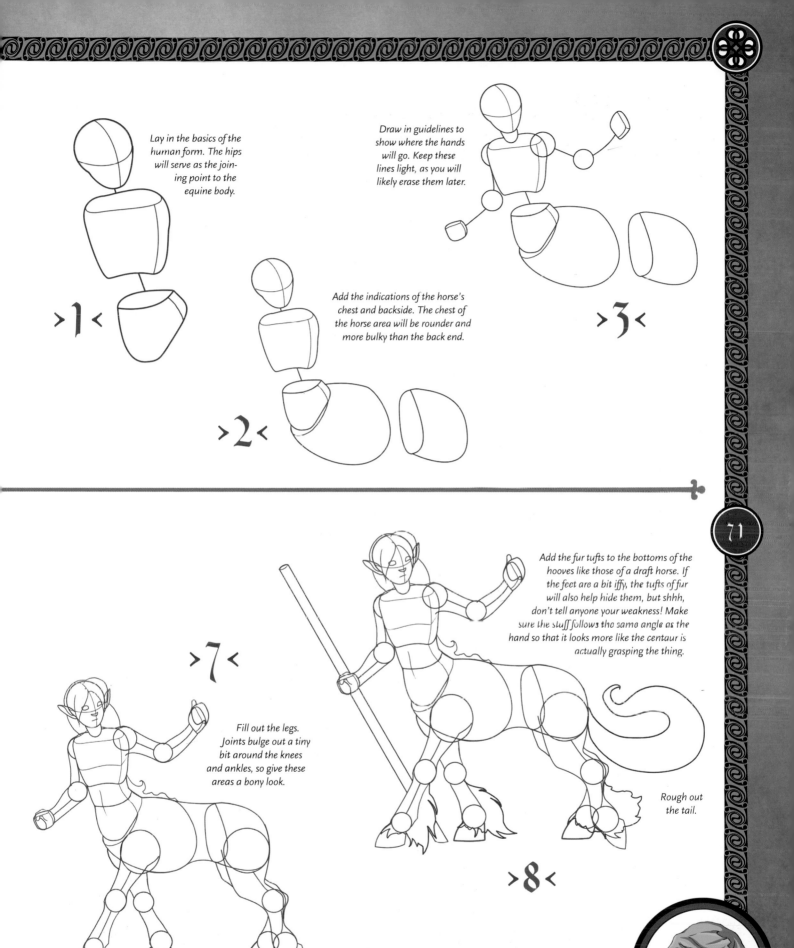

Lay in the basics of the human form. The hips will serve as the joining point to the equine body.

>1<

Add the indications of the horse's chest and backside. The chest of the horse area will be rounder and more bulky than the back end.

>2<

Draw in guidelines to show where the hands will go. Keep these lines light, as you will likely erase them later.

>3<

Fill out the legs. Joints bulge out a tiny bit around the knees and ankles, so give these areas a bony look.

>7<

Add the fur tufts to the bottoms of the hooves like those of a draft horse. If the feet are a bit iffy, the tufts of fur will also help hide them, but shhh, don't tell anyone your weakness! Make sure the stuff follows the same angle as the hand so that it looks more like the centaur is actually grasping the thing.

Rough out the tail.

>8<

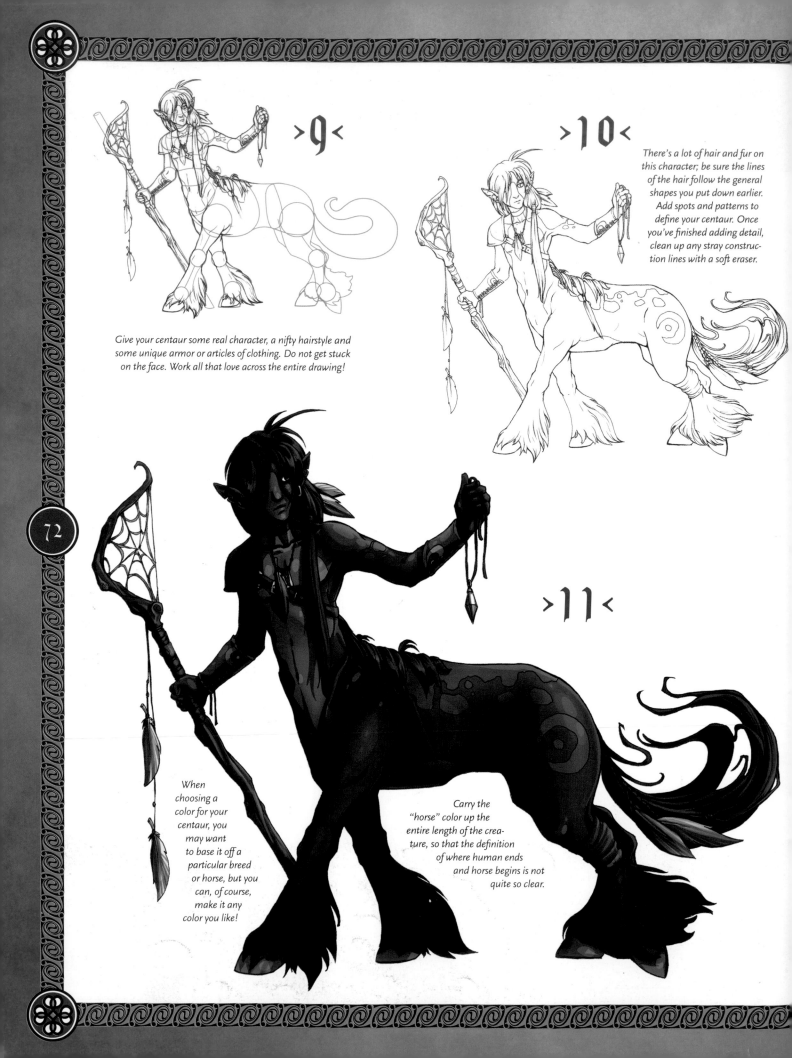

>9<

Give your centaur some real character, a nifty hairstyle and some unique armor or articles of clothing. Do not get stuck on the face. Work all that love across the entire drawing!

>10<

There's a lot of hair and fur on this character; be sure the lines of the hair follow the general shapes you put down earlier. Add spots and patterns to define your centaur. Once you've finished adding detail, clean up any stray construction lines with a soft eraser.

>11<

When choosing a color for your centaur, you may want to base it off a particular breed or horse, but you can, of course, make it any color you like!

Carry the "horse" color up the entire length of the creature, so that the definition of where human ends and horse begins is not quite so clear.

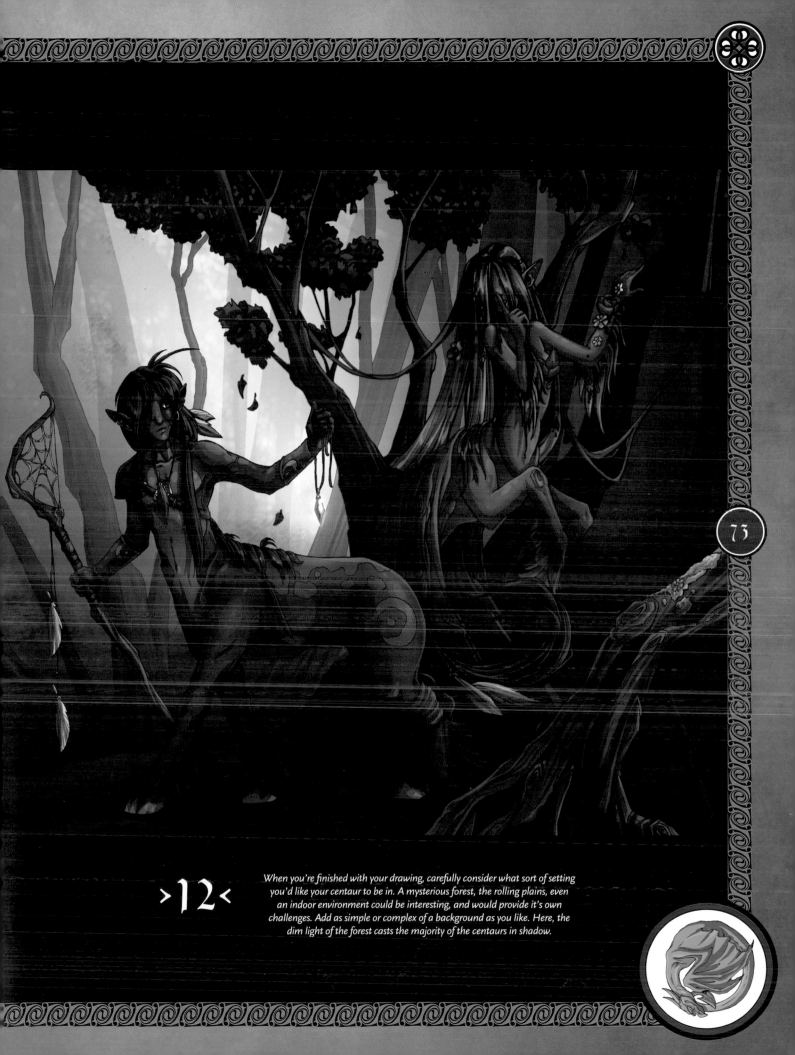

>12<

When you're finished with your drawing, carefully consider what sort of setting you'd like your centaur to be in. A mysterious forest, the rolling plains, even an indoor environment could be interesting, and would provide it's own challenges. Add as simple or complex of a background as you like. Here, the dim light of the forest casts the majority of the centaurs in shadow.

Faun

The faun is a creature of Roman mythology. These woodland spirits resemble humans above the waist and goats below. They are often seen carrying a pan flute. Fauns were supposedly fun-loving creatures who enjoyed drinking, dancing and music.

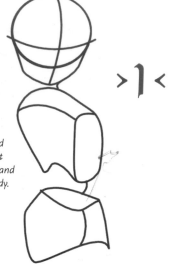

>1<

Rough in the basics of the human form. Place the shape of the head, chest and hips to give an idea of what direction the faun is facing and the positioning of the body.

Lay in construction lines for smaller things, such as the ears, tail, hooves and hands. For more information on drawing hooves, see page 69. Draw an extra fluffy goat's tail to give some interest to the right side of the page. Add a box that will become a pan flute.

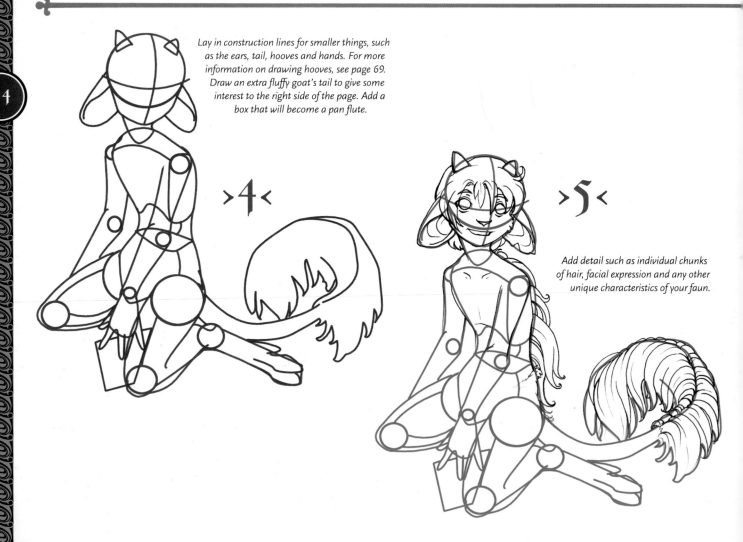

>4<

>5<

Add detail such as individual chunks of hair, facial expression and any other unique characteristics of your faun.

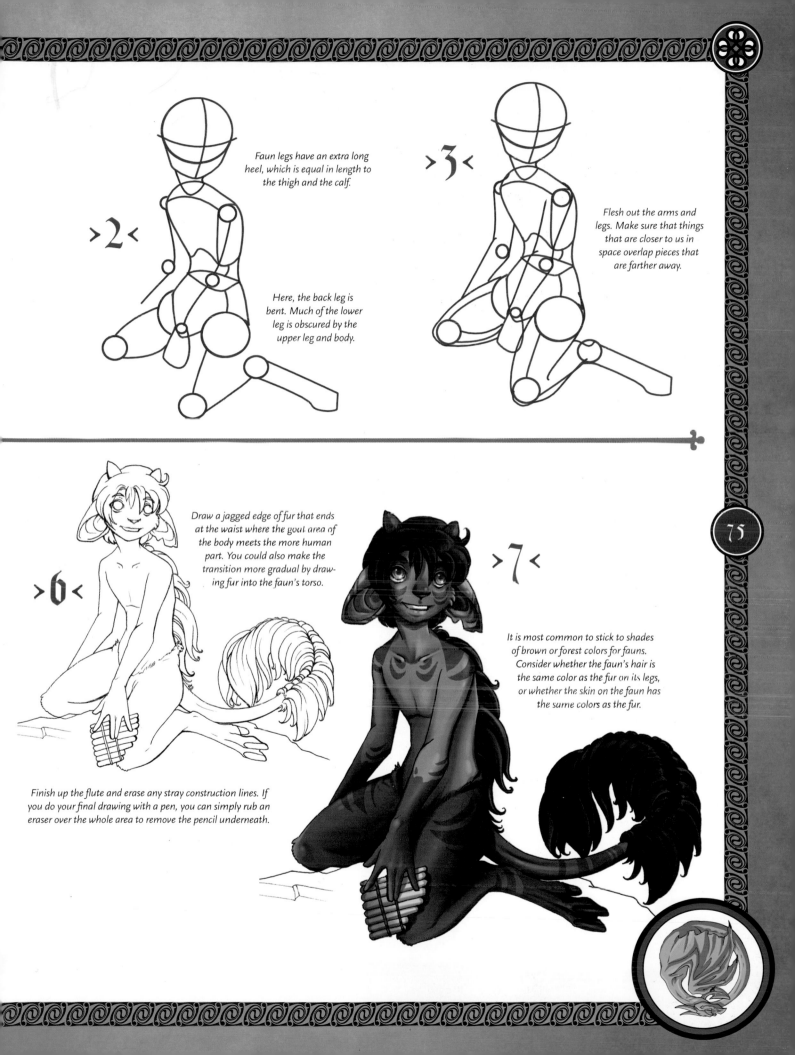

>2<

Faun legs have an extra long heel, which is equal in length to the thigh and the calf.

Here, the back leg is bent. Much of the lower leg is obscured by the upper leg and body.

>3<

Flesh out the arms and legs. Make sure that things that are closer to us in space overlap pieces that are farther away.

>6<

Draw a jagged edge of fur that ends at the waist where the goat area of the body meets the more human part. You could also make the transition more gradual by drawing fur into the faun's torso.

Finish up the flute and erase any stray construction lines. If you do your final drawing with a pen, you can simply rub an eraser over the whole area to remove the pencil underneath.

>7<

It is most common to stick to shades of brown or forest colors for fauns. Consider whether the faun's hair is the same color as the fur on its legs, or whether the skin on the faun has the same colors as the fur.

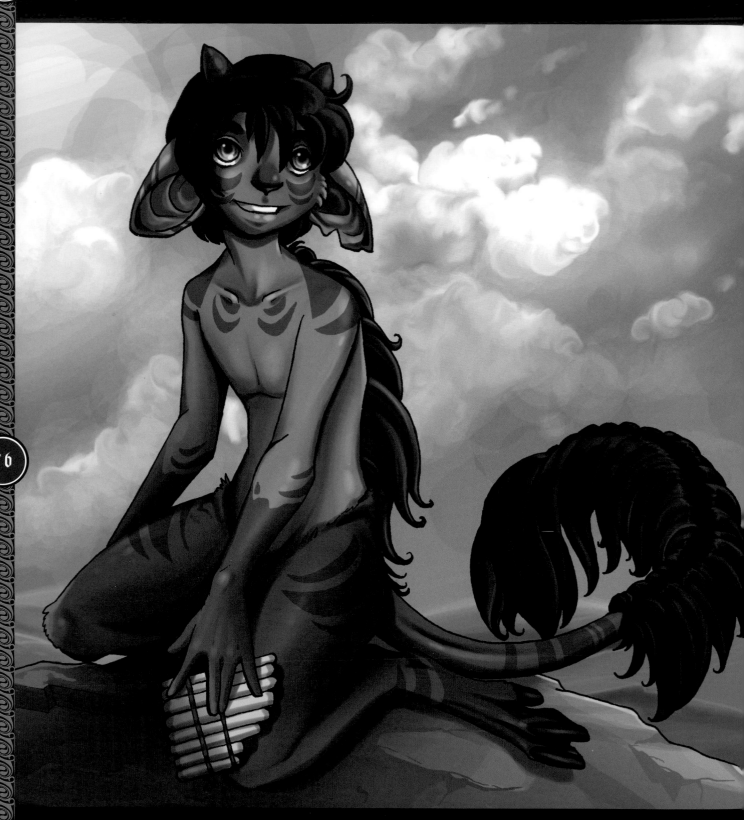

> 8 <

Finish off your drawing with a place for your faun to hang out. It can be as lavish as an entire enchanted wood, or as simple as a rock to sit on.

BIRD WINGS

From the sphinx to the harpy, feathered wings are an important part of many fantasy characters.

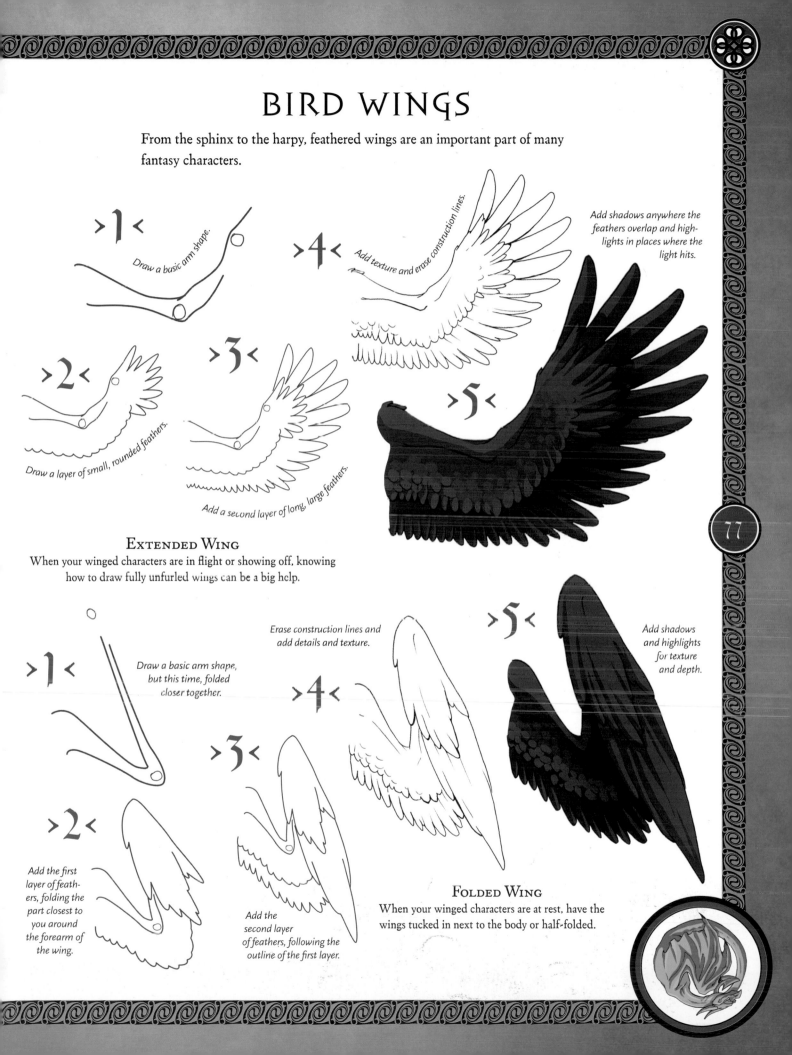

>1<
Draw a basic arm shape.

>2<
Draw a layer of small, rounded feathers.

>3<
Add a second layer of long, large feathers.

>4<
Add texture and erase construction lines.

Add shadows anywhere the feathers overlap and highlights in places where the light hits.

>5<

EXTENDED WING

When your winged characters are in flight or showing off, knowing how to draw fully unfurled wings can be a big help.

>1<
Draw a basic arm shape, but this time, folded closer together.

>2<
Add the first layer of feathers, folding the part closest to you around the forearm of the wing.

>3<
Add the second layer of feathers, following the outline of the first layer.

>4<
Erase construction lines and add details and texture.

>5<
Add shadows and highlights for texture and depth.

FOLDED WING

When your winged characters are at rest, have the wings tucked in next to the body or half-folded.

Angel

Traditionally, angels are messengers of a higher power. Throughout the course of fantasy and myth, other winged beings of a less divine nature have sprung up. Avariels, harpies and other winged people are very common, and very fun to draw!

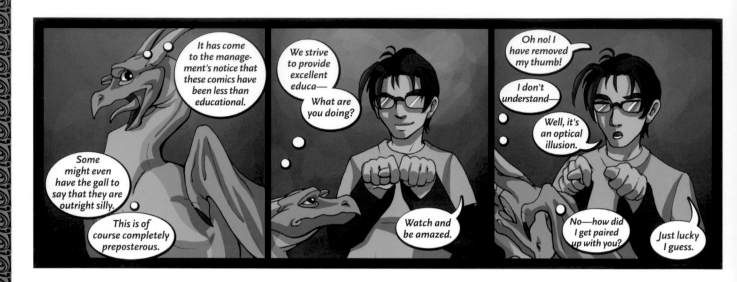

Draw the skull and jawline. Draw a neck connecting the head and shoulders.

Create a continuous torso with lines connecting the chest and hips.

>3<

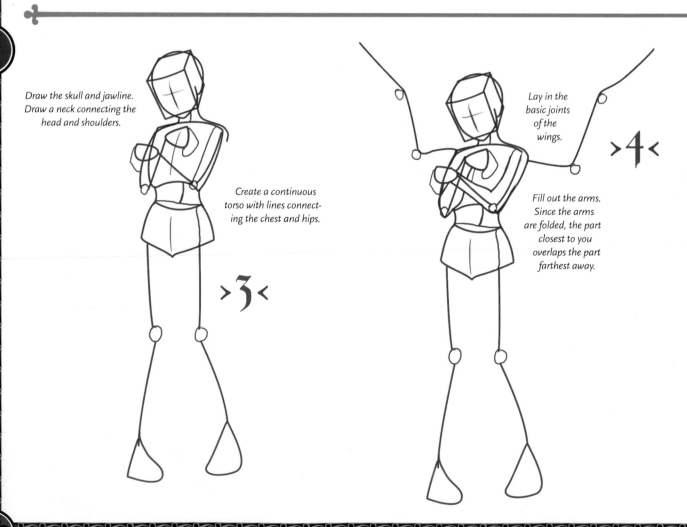

Lay in the basic joints of the wings.

>4<

Fill out the arms. Since the arms are folded, the part closest to you overlaps the part farthest away.

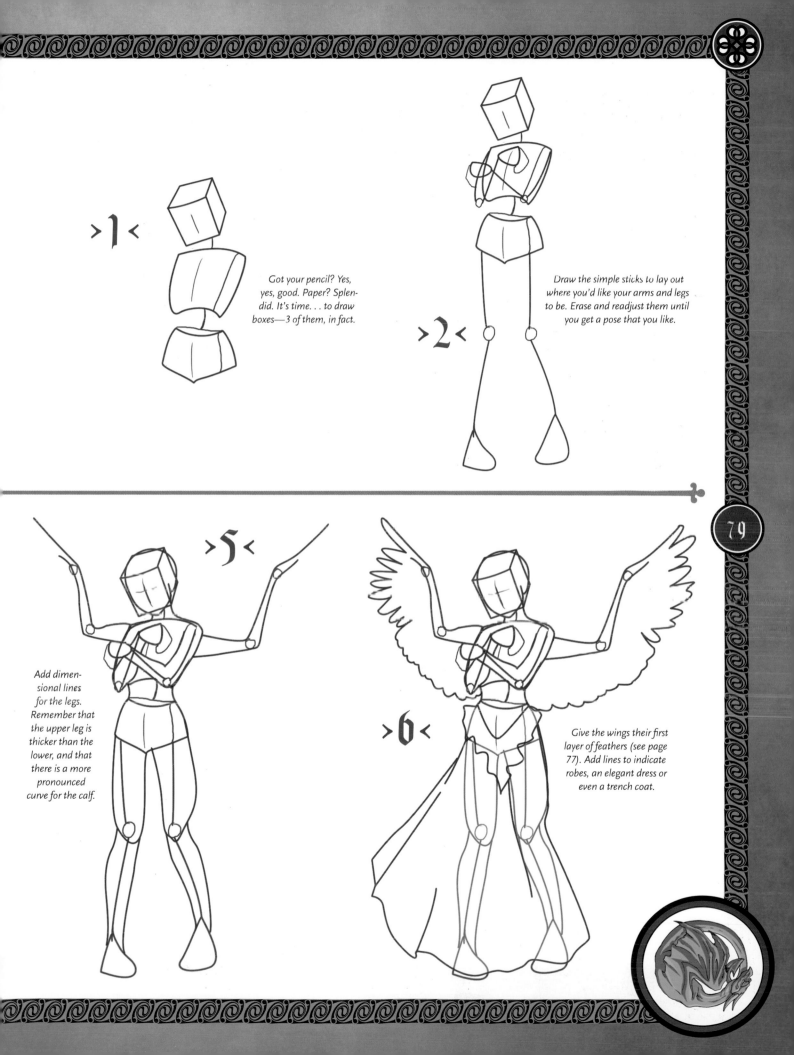

>1<

Got your pencil? Yes, yes, good. Paper? Splendid. It's time. . . to draw boxes—3 of them, in fact.

>2<

Draw the simple sticks to lay out where you'd like your arms and legs to be. Erase and readjust them until you get a pose that you like.

>5<

Add dimensional lines for the legs. Remember that the upper leg is thicker than the lower, and that there is a more pronounced curve for the calf.

>6<

Give the wings their first layer of feathers (see page 77). Add lines to indicate robes, an elegant dress or even a trench coat.

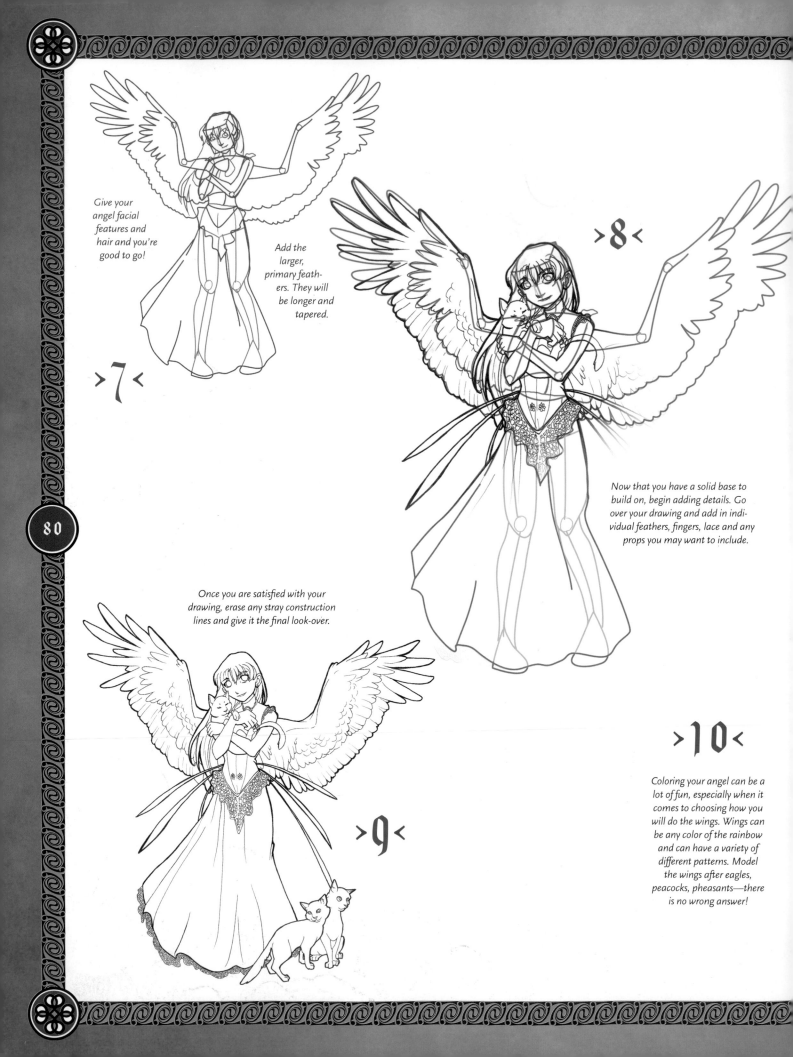

Give your angel facial features and hair and you're good to go!

>7<

Add the larger, primary feathers. They will be longer and tapered.

>8<

Now that you have a solid base to build on, begin adding details. Go over your drawing and add in individual feathers, fingers, lace and any props you may want to include.

Once you are satisfied with your drawing, erase any stray construction lines and give it the final look-over.

>9<

>10<

Coloring your angel can be a lot of fun, especially when it comes to choosing how you will do the wings. Wings can be any color of the rainbow and can have a variety of different patterns. Model the wings after eagles, peacocks, pheasants—there is no wrong answer!

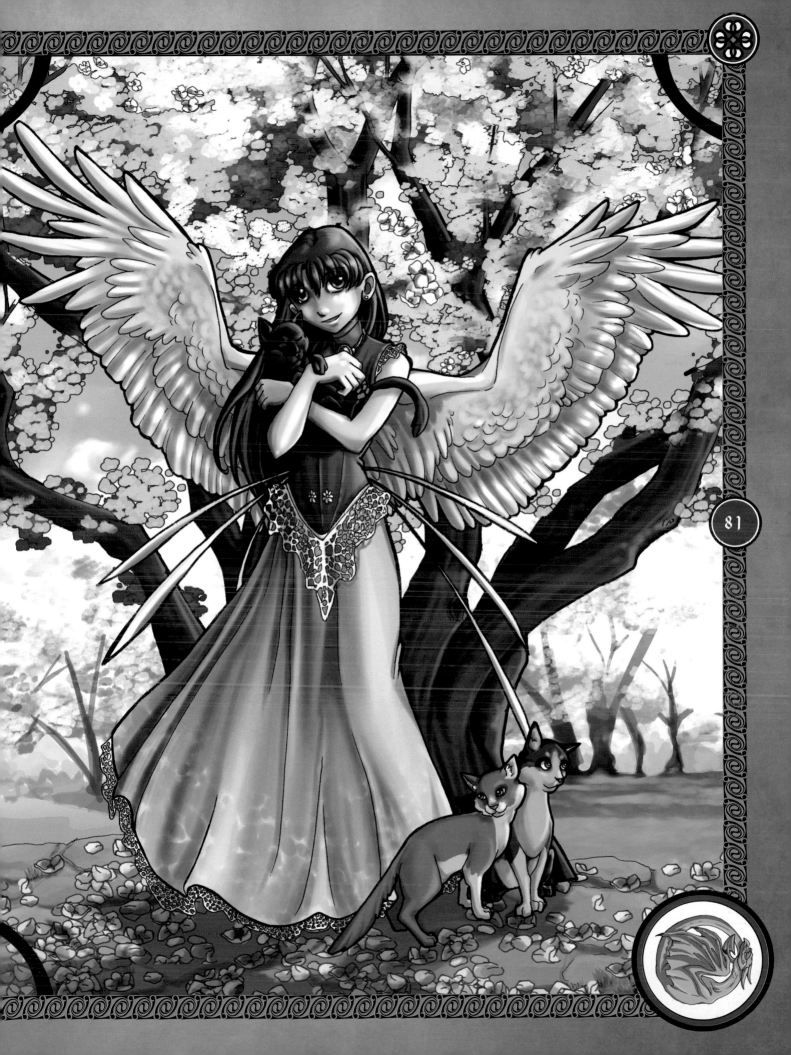

Kitsune

Kitsune are fantasy characters that originated in the East. These fox spirits possess many powers, the foremost being the ability to assume human form. As the kitsune grows in age and power, the number of tails it possesses increases, the most powerful having as many as nine.

> *Just*
> INCOMPETENT MINION AND DOLOSUS PRESENTS
>
> Incredibly Educational Information

> Welcome to this exciting new segment, Incredibly Educational Information.
>
> Or as I like to call it, IEI. (Don't try to pronounce it.)
>
> In these 3 incredibly educational panels, we strive for excellence.
>
> I am your devilishly handsome host, Dolosus.

> THAT'S ALL THE PANELS WE HAVE FOR TODAY. THANK YOU FOR ENJOYING ANOTHER SEGMENT OF:
>
> Incredibly Educational Information

>3<

Follow the size relationship and direction you indicated with the box representing the head, draw in a snout and two large ears. The eyes will still be half-way down the head. The snout can be as short as a human nose, or longer, like a fox's.

Draw lines connecting your character's hips and chest.

>4<

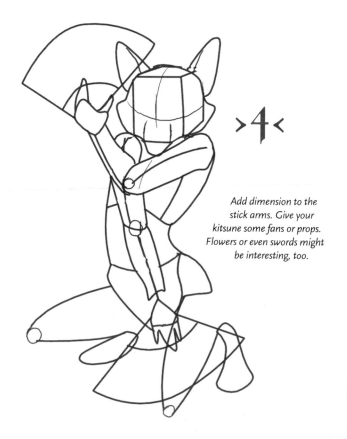

Add dimension to the stick arms. Give your kitsune some fans or props. Flowers or even swords might be interesting, too.

>1<

Draw boxes to indicate direction and position of the head, chest and hips. Here, the head is pushed down, overlapping the chest.

Draw jointed lines to position the arms and legs.

For this pose, the kitsune is crouched down, with arms crossing.

>2<

>5<

The more tails a kitsune has, the greater its power.

However, the more tails you add, the busier your drawing will become. Plan in advance how you would like to position the tails.

Position the eyes halfway down the head, evenly spaced on either side of the snout.

Add dimension to her legs, overlapping where appropriate.

>6<

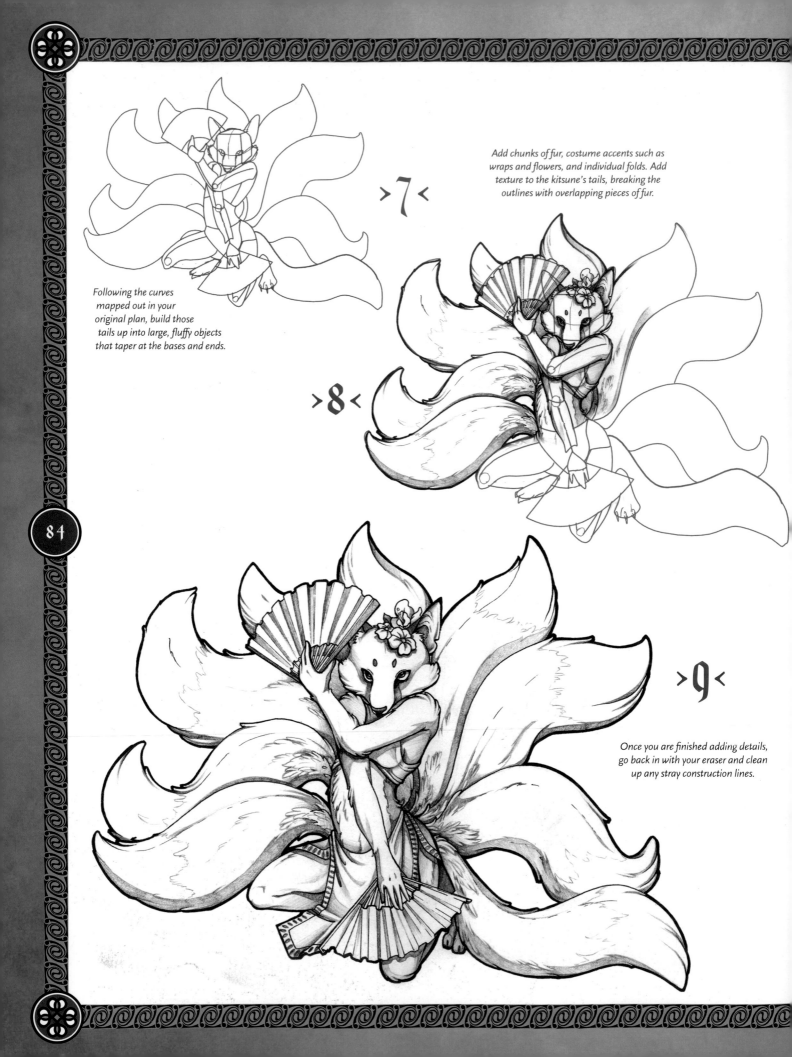

> 7 <

Add chunks of fur, costume accents such as wraps and flowers, and individual folds. Add texture to the kitsune's tails, breaking the outlines with overlapping pieces of fur.

Following the curves mapped out in your original plan, build those tails up into large, fluffy objects that taper at the bases and ends.

> 8 <

> 9 <

Once you are finished adding details, go back in with your eraser and clean up any stray construction lines.

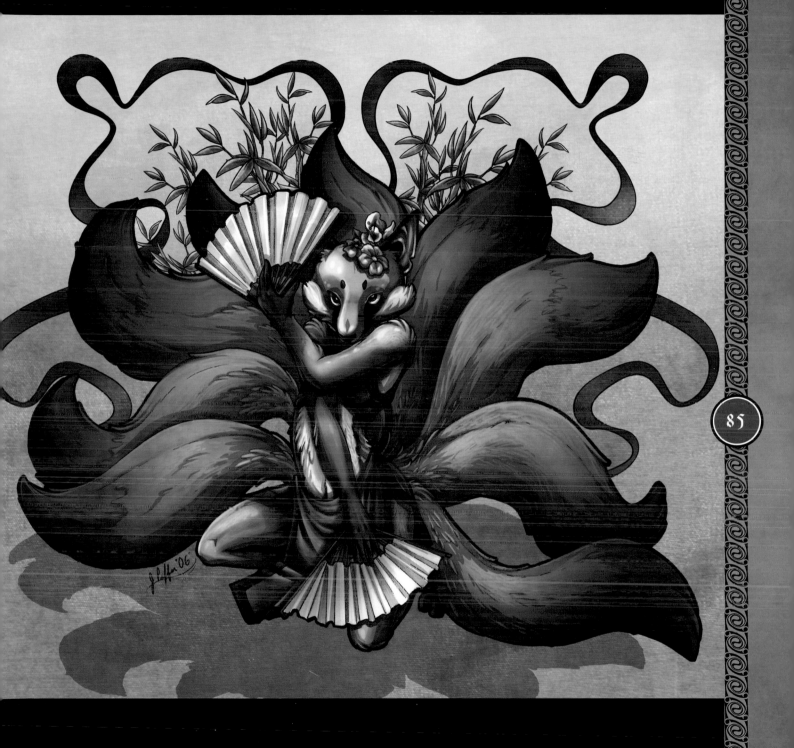

>10<

A kitsune can be white as snow or many shades of auburn, just like a fox in the wild. Maybe you don't want to go with a standard fox color and would instead like a gold, blue, or even green character!

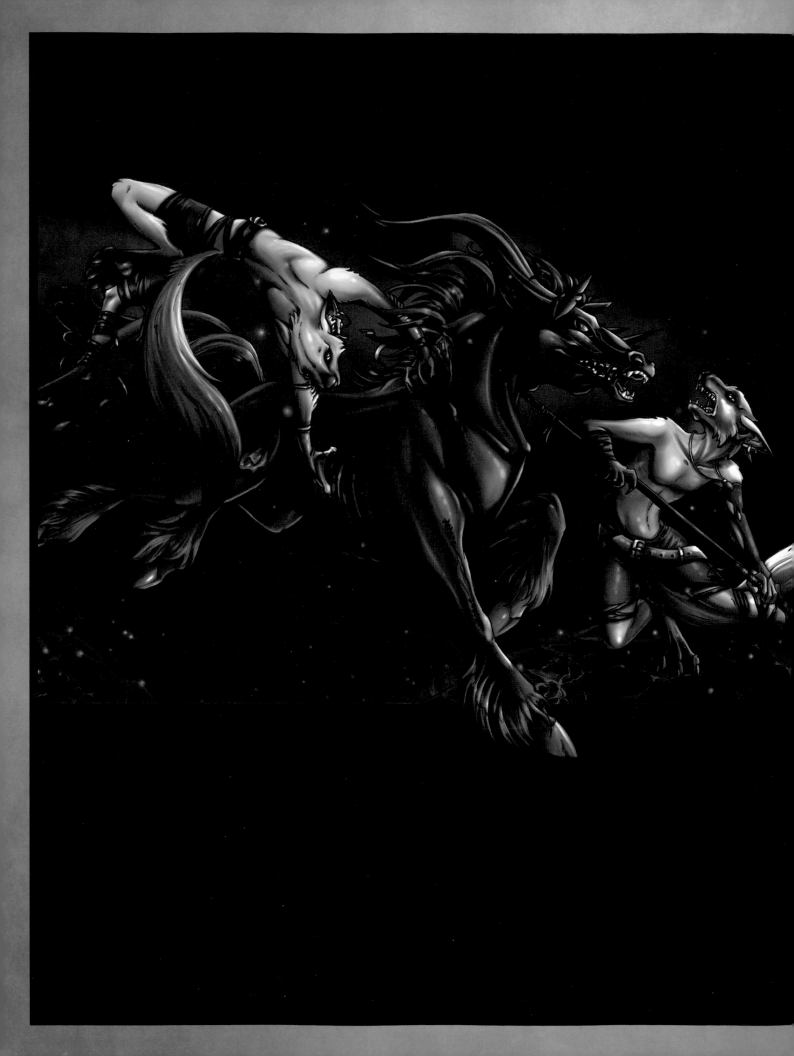

part 3

THINGS THAT GO
BUMP in the NIGHT

FANTASY ISN'T ALL FAIRIES AND DRAGONS. NOT ALL MYTHS AND LEGENDS HAVE HAPPY ENDINGS. SOMETIMES THERE'S SOMETHING QUIETLY LURKING IN THE CORNER. SOMETHING SINISTER. SOMETHING THAT MAKES A BUMP IN THE NIGHT, THEN DISAPPEARS JUST AS QUICKLY. . . YOU HOPE.

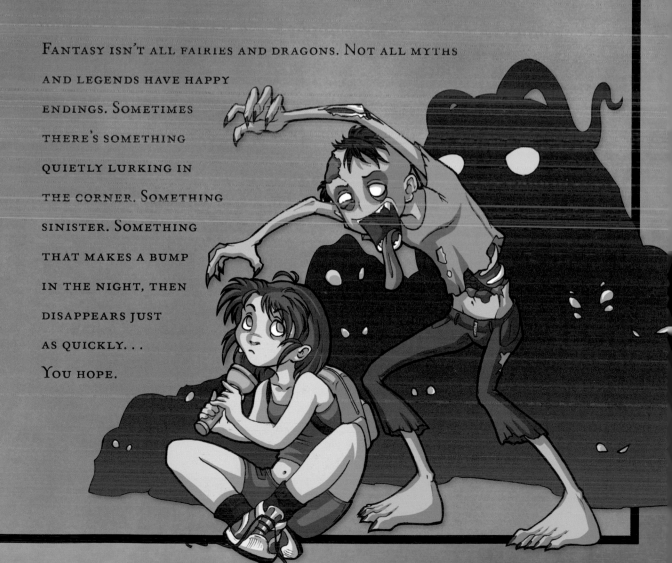

Banshee

The banshee is a female spirit of Irish mythology. This unusual fairy is said to emit a mournful wail. If heard from a distance, it portends when someone will die. To hear and see the banshee up close may foretell your own death.

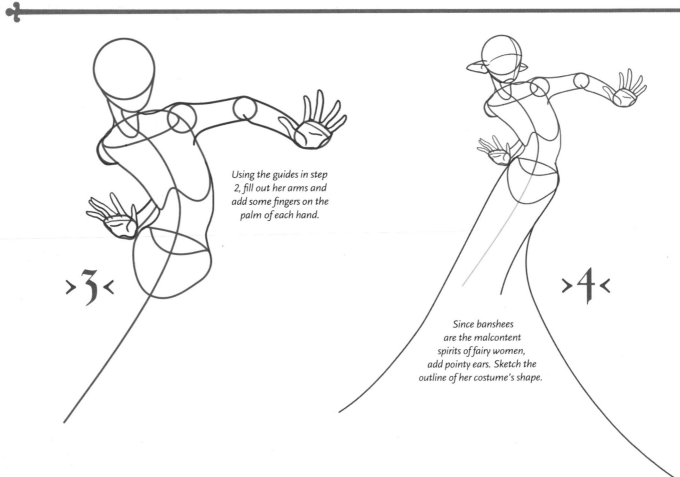

Using the guides in step 2, fill out her arms and add some fingers on the palm of each hand.

>3<

Since banshees are the malcontent spirits of fairy women, add pointy ears. Sketch the outline of her costume's shape.

>4<

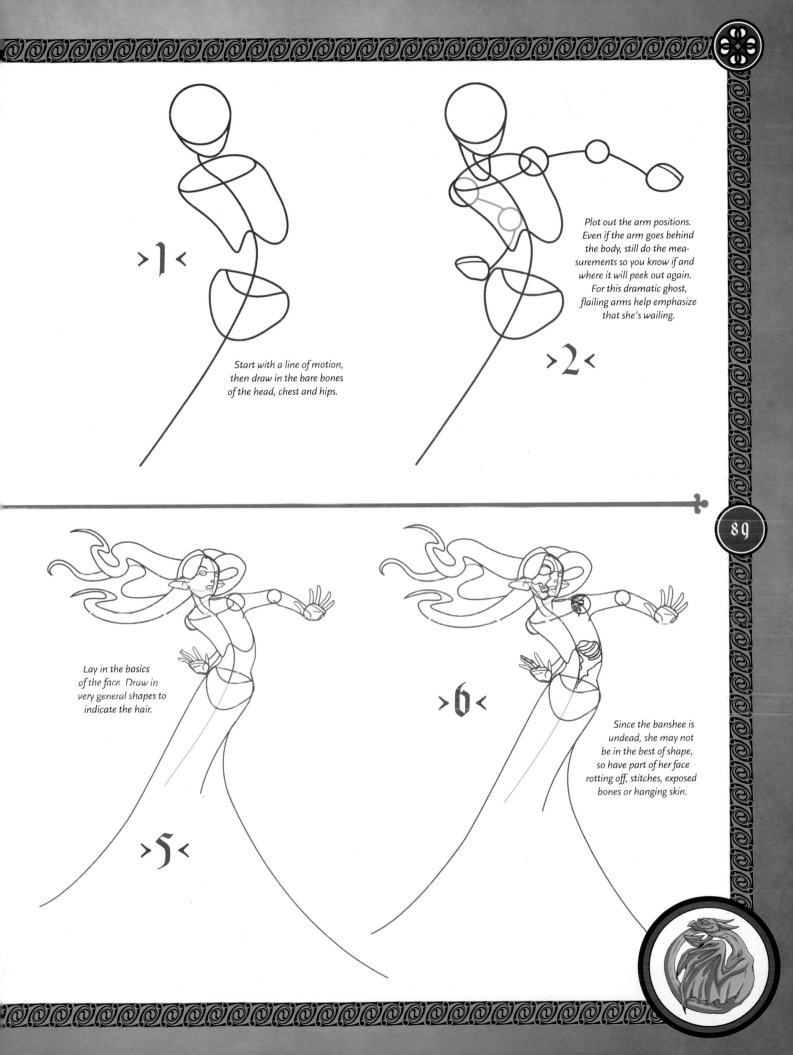

>1<

Start with a line of motion, then draw in the bare bones of the head, chest and hips.

>2<

Plot out the arm positions. Even if the arm goes behind the body, still do the measurements so you know if and where it will peek out again. For this dramatic ghost, flailing arms help emphasize that she's wailing.

>5<

Lay in the basics of the face. Draw in very general shapes to indicate the hair.

>6<

Since the banshee is undead, she may not be in the best of shape, so have part of her face rotting off, stitches, exposed bones or hanging skin.

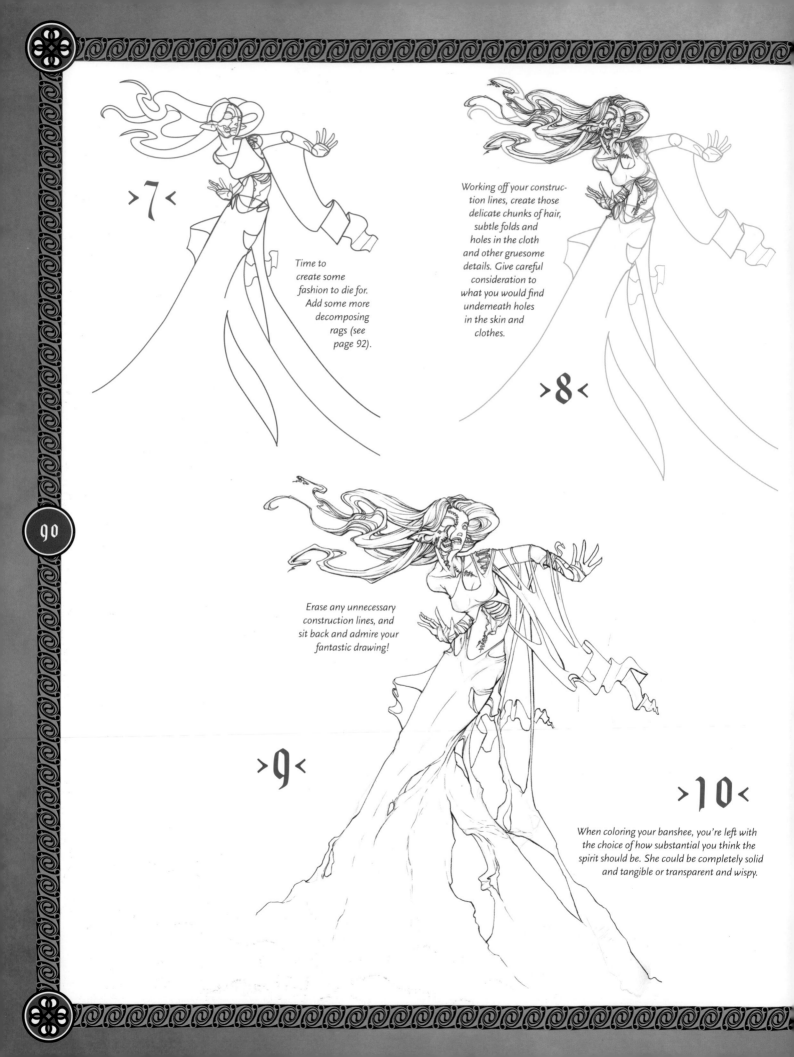

>7<

Time to
create some
fashion to die for.
Add some more
decomposing
rags (see
page 92).

Working off your construc-
tion lines, create those
delicate chunks of hair,
subtle folds and
holes in the cloth
and other gruesome
details. Give careful
consideration to
what you would find
underneath holes
in the skin and
clothes.

>8<

Erase any unnecessary
construction lines, and
sit back and admire your
fantastic drawing!

>9<

>10<

When coloring your banshee, you're left with
the choice of how substantial you think the
spirit should be. She could be completely solid
and tangible or transparent and wispy.

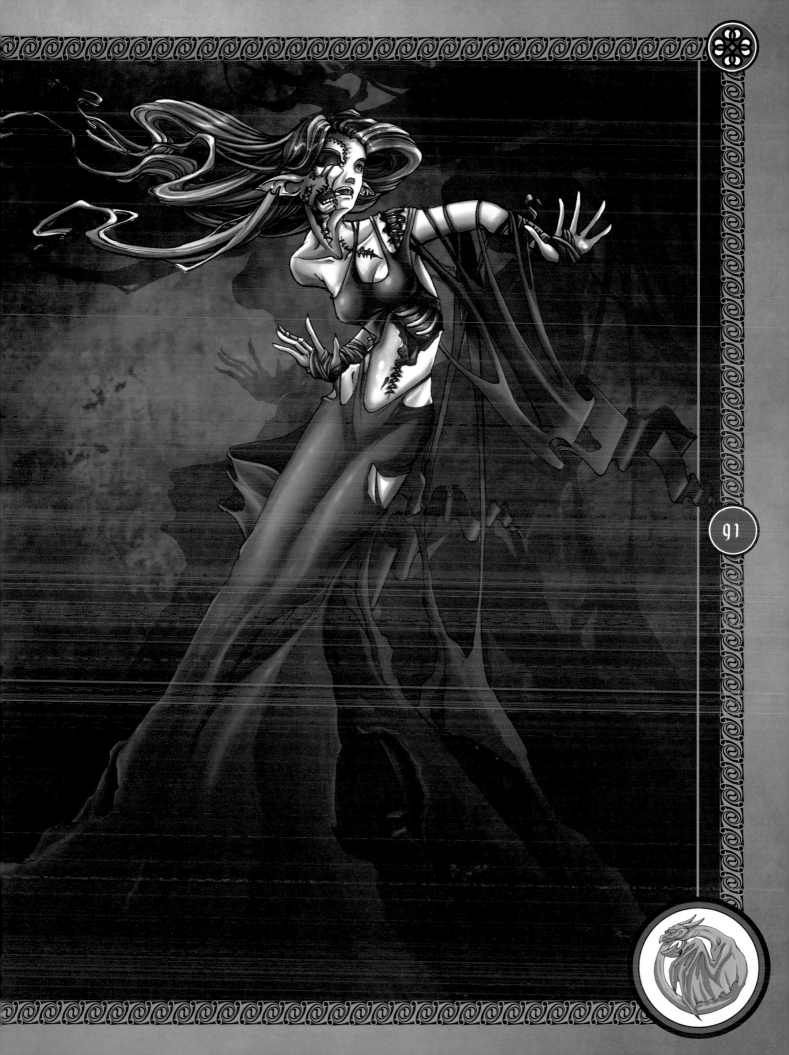

TATTERED GARMENTS

Quite often, the clothes of fantasy characters will not be in 100-percent perfect shape. Here are some quick ideas for different ways to wear-and-tear and tatter your characters' garments.

New Cloth
A perfect piece of cloth. How dull!

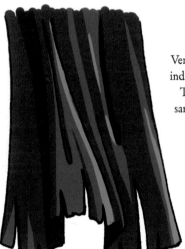

Vertical Rips
Vertical rips in the edges of cloth indicate just a little wear-and-tear. The cloth still flows much the same as it would if it were whole.

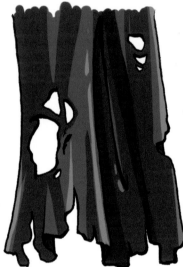

Moth Holes
Punch giant holes out of the cloth to make it look moth-eaten. Add more random rips around the edges, too.

Threadbare Rags
Show threadbare rags by giving the holes in your garment lingering threads connecting the pieces together. . . barely. This is the same phenomenon that happens when you get rips in the knees of your stockings or jeans.

Utter Decay
This piece of cloth is so ripped up and tattered, it's lost much of its original shape. This scary looking blob cloth is not particularly realistic. . . but when you're drawing people with wings and pointy ears, does realism really matter?

BAT WINGS

Bat wings are used as a basis for most dragon wings, as well as for your garden variety vampires and other demon-types. Bat wings are actually arms and paws with extremely long fingers and skin that grows between them.

>1<

A folded wing has the same arm-hand setup as an unfolded wing, but the part that is folded overlaps the wing base.

>2<

Connect each of the joints with an upside down U-shape.

>3<

Add tatters and holes to make it look scary.

Each wrinkle should have a main high-light where the light hits and dark shadows in the creases.

>4<

FOLDED WING
Wings are large and can get in the way. When your character is at rest or you just want to take up less room on that sheet of paper, a folded wing is a good option.

EXTENDED WING
Use an extended wing when your winged character is flying or trying to look impressive.

>1<

Begin your wing with a simple arm shape. At the end, draw a circular shape to represent the palm, then evenly space out 3 to 5 long fingers.

>2<

Connect each segment with upside down U-shapes.

>3<

For a more evil, battle-worn wing, tatters and holes are nice additions.

>4<

There will be more highlights in the main portion of the webbing where the skin is more translucent.

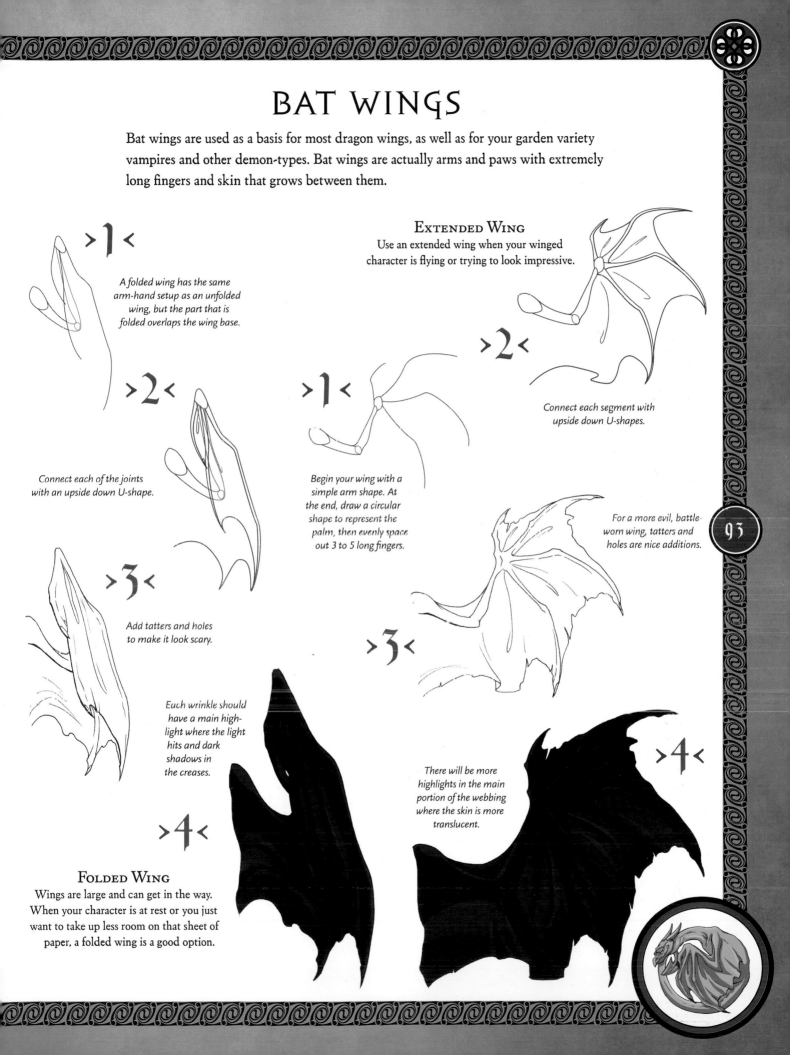

Vampire

Creatures of the night, vampires are a very common element in modern fantasy and horror. These beings are often the reanimated corpses of the dead that sustain themselves on the blood of the living. Common characteristics would be a pale complexion, a set of impressive fangs, and an aversion towards sunlight.

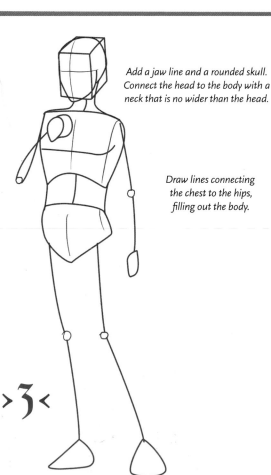

Add a jaw line and a rounded skull. Connect the head to the body with a neck that is no wider than the head.

Draw lines connecting the chest to the hips, filling out the body.

>3<

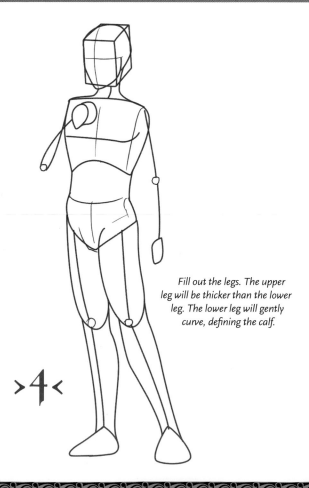

Fill out the legs. The upper leg will be thicker than the lower leg. The lower leg will gently curve, defining the calf.

>4<

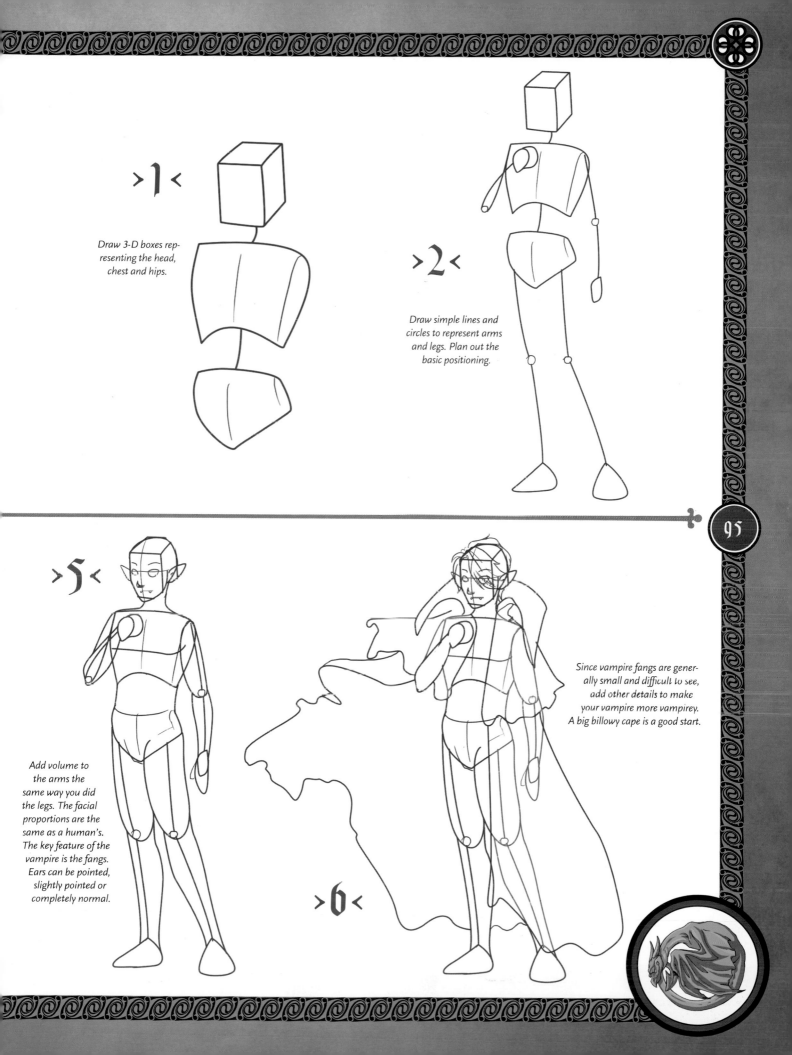

>1<

Draw 3-D boxes representing the head, chest and hips.

>2<

Draw simple lines and circles to represent arms and legs. Plan out the basic positioning.

>5<

Add volume to the arms the same way you did the legs. The facial proportions are the same as a human's. The key feature of the vampire is the fangs. Ears can be pointed, slightly pointed or completely normal.

>6<

Since vampire fangs are generally small and difficult to see, add other details to make your vampire more vampirey. A big billowy cape is a good start.

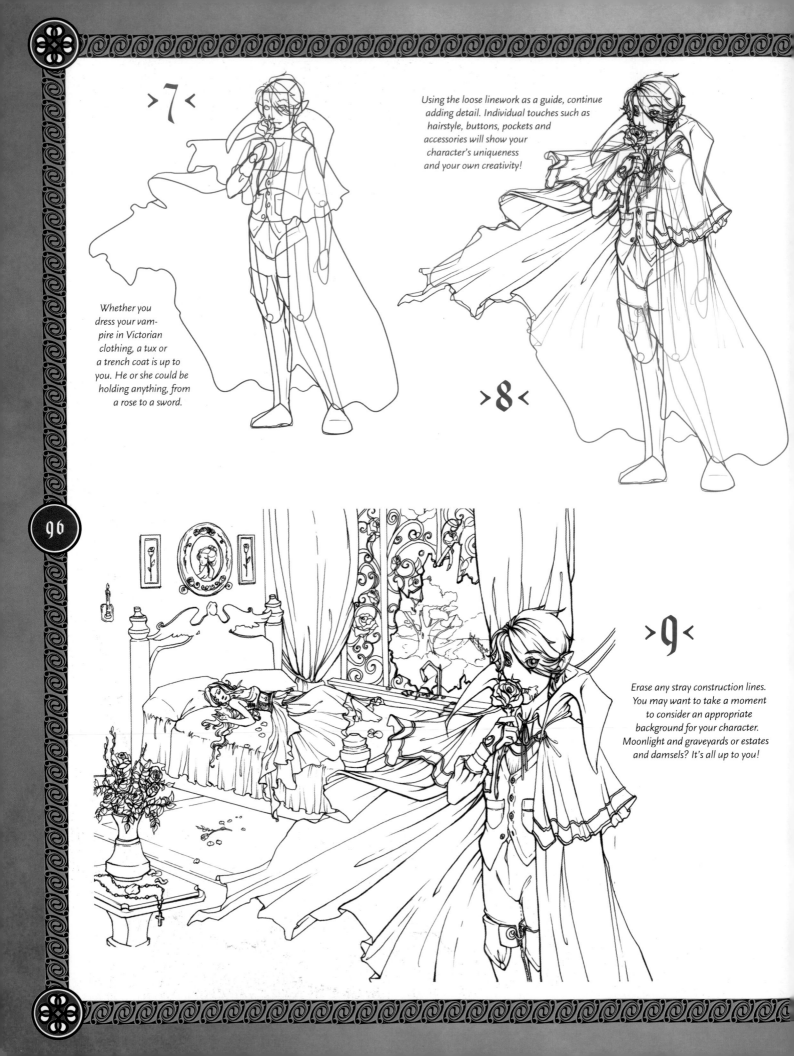

>7<

Using the loose linework as a guide, continue adding detail. Individual touches such as hairstyle, buttons, pockets and accessories will show your character's uniqueness and your own creativity!

Whether you dress your vampire in Victorian clothing, a tux or a trench coat is up to you. He or she could be holding anything, from a rose to a sword.

>8<

>9<

Erase any stray construction lines. You may want to take a moment to consider an appropriate background for your character. Moonlight and graveyards or estates and damsels? It's all up to you!

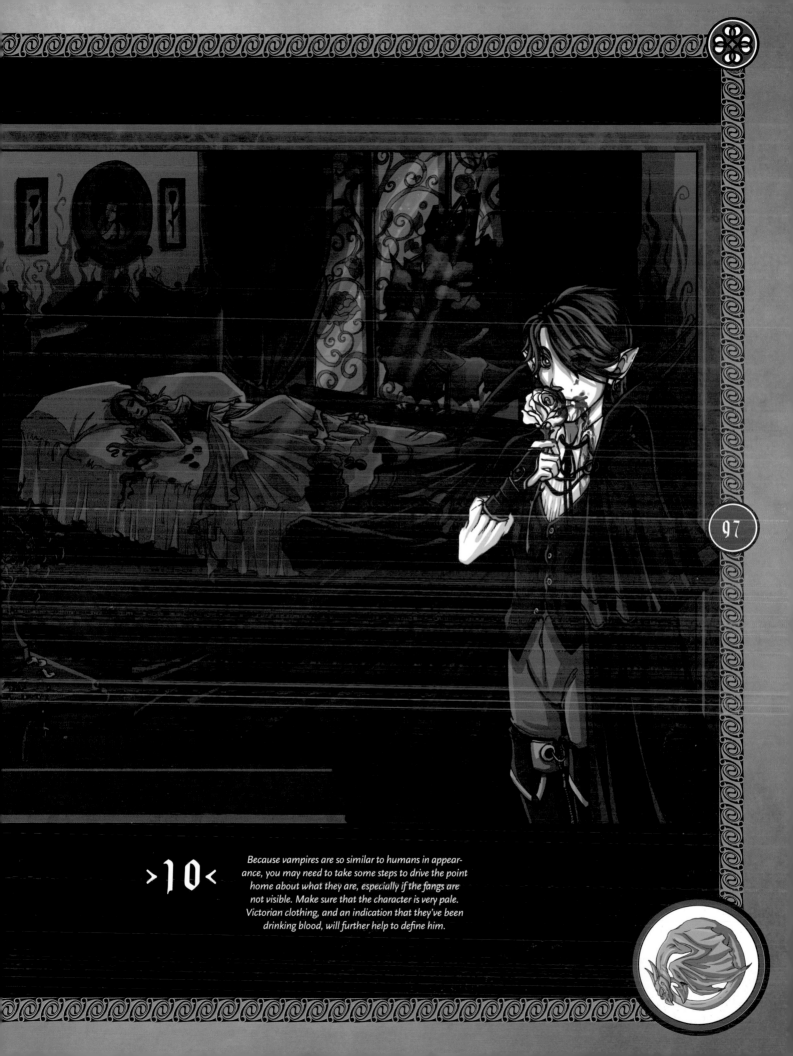

>10<

Because vampires are so similar to humans in appearance, you may need to take some steps to drive the point home about what they are, especially if the fangs are not visible. Make sure that the character is very pale. Victorian clothing, and an indication that they've been drinking blood, will further help to define him.

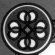

Werewolf

A werewolf is typically a human that is cursed to turn into a wolf or wolfman by the light of the full moon. Monstrous creatures when they transform, they can only be hurt by weapons made of silver. Werewolf characters can be very fun to draw because you get to design a human form and a wolf counterpart.

The biggest leap in a drawing is from construction lines, to the details.

The little stuff is what makes your drawing unique to you.

Character expression, costuming, and your own personal drawing quirks give the drawing life!

Don't be afraid to try new things or think outside the box. The step-by-step guides in this book are merely a starting point. Don't let them limit you. The book is only 128 pages long. Your imagination is endless!

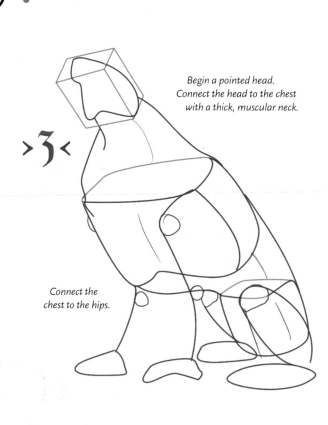

> 3 <

Begin a pointed head. Connect the head to the chest with a thick, muscular neck.

Connect the chest to the hips.

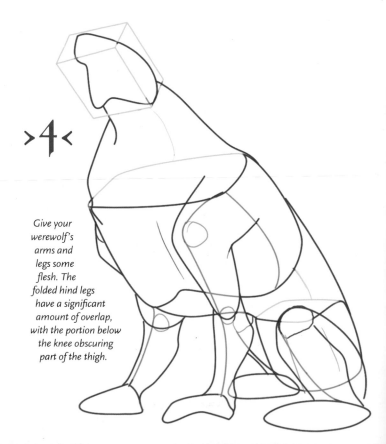

> 4 <

Give your werewolf's arms and legs some flesh. The folded hind legs have a significant amount of overlap, with the portion below the knee obscuring part of the thigh.

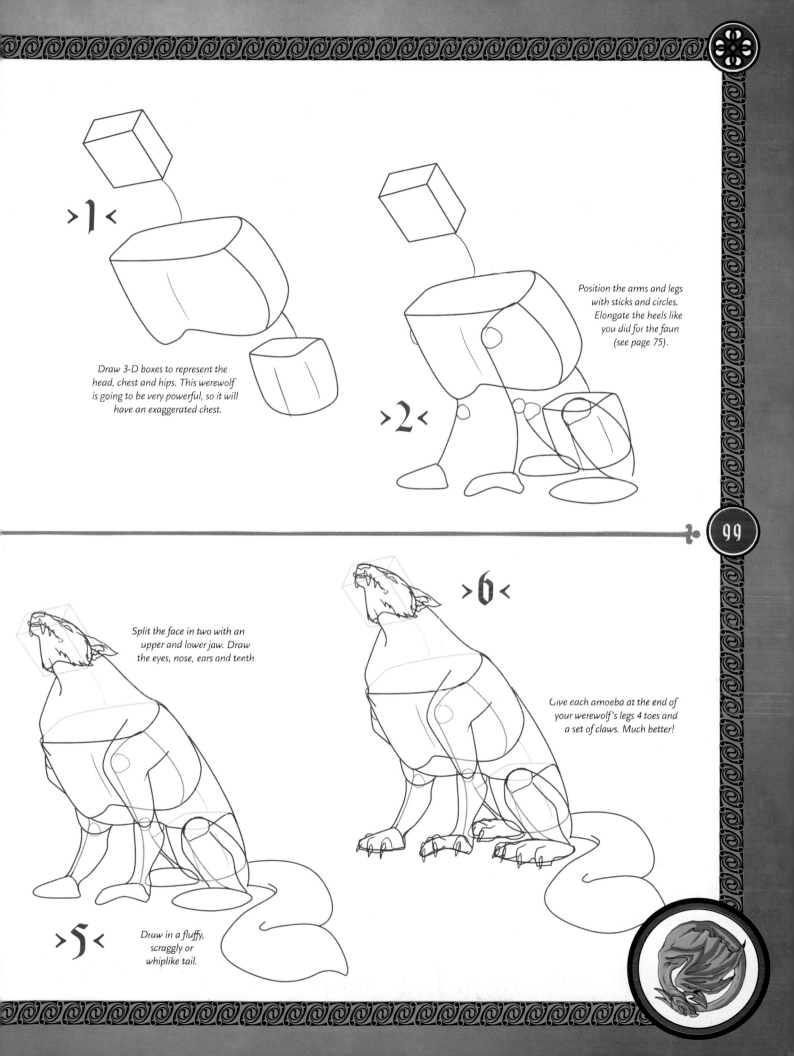

>1<

Draw 3-D boxes to represent the head, chest and hips. This werewolf is going to be very powerful, so it will have an exaggerated chest.

>2<

Position the arms and legs with sticks and circles. Elongate the heels like you did for the faun (see page 75).

>5<

Draw in a fluffy, scraggly or whiplike tail.

Split the face in two with an upper and lower jaw. Draw the eyes, nose, ears and teeth.

>6<

Give each amoeba at the end of your werewolf's legs 4 toes and a set of claws. Much better!

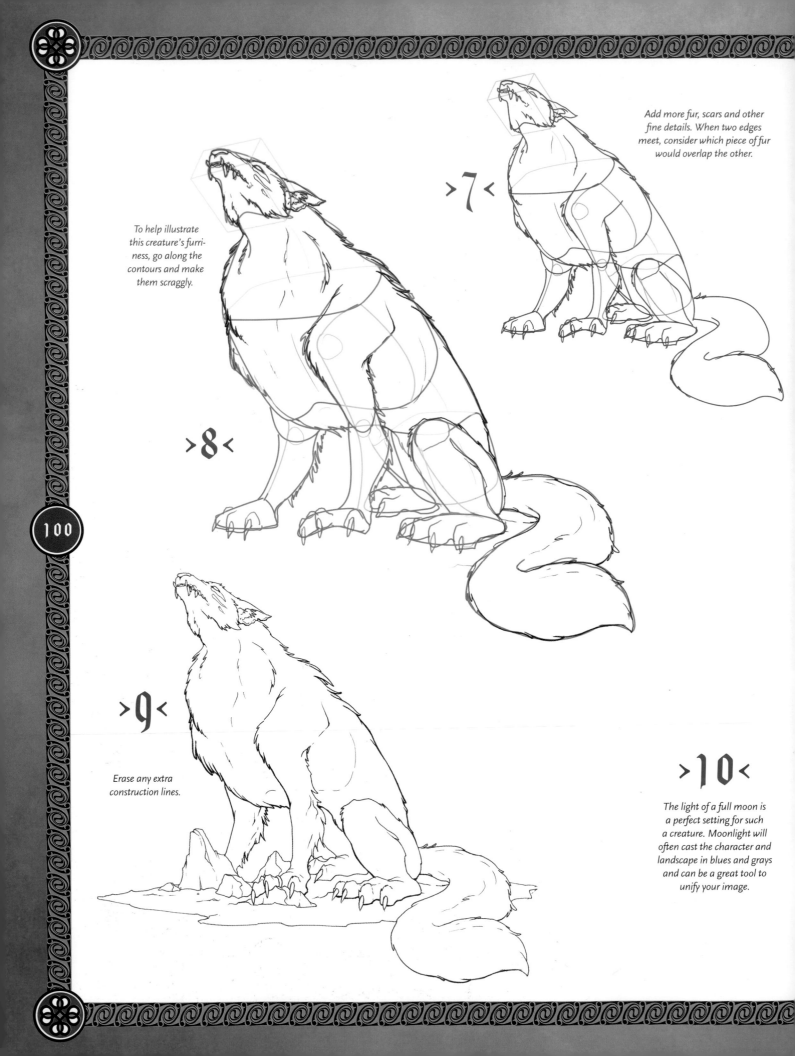

Add more fur, scars and other fine details. When two edges meet, consider which piece of fur would overlap the other.

>7<

To help illustrate this creature's furriness, go along the contours and make them scraggly.

>8<

Erase any extra construction lines.

>9<

>10<

The light of a full moon is a perfect setting for such a creature. Moonlight will often cast the character and landscape in blues and grays and can be a great tool to unify your image.

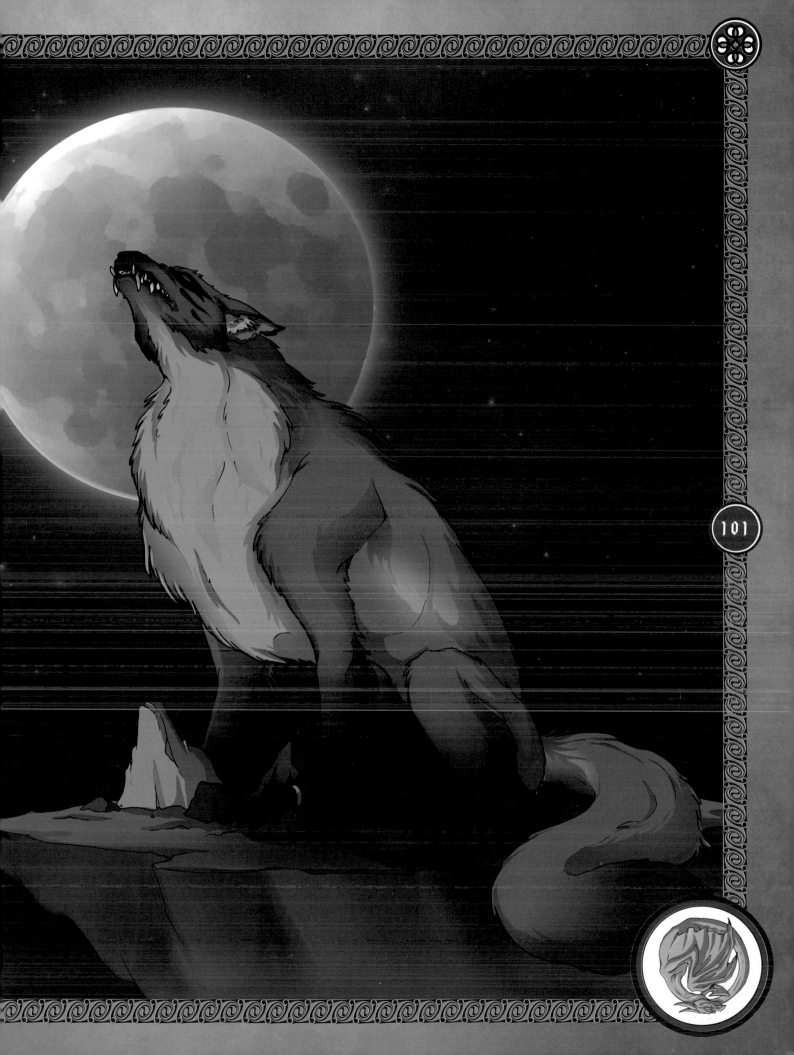

Demon

Demons and fiends often live on another plane and come to the real world to stir up mischief and cause as much trouble as they can. These creatures can have physical attributes from a variety of different animals, so designing a demon can be a lot of fun because there's so much to choose from.

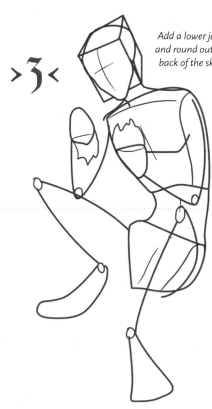

Add a lower jaw and round out the back of the skull.

> 3 <

Connect the head to the chest, and the chest to the hips.

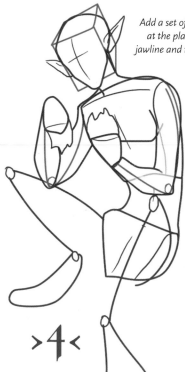

Add a set of pointed ears that attach at the place where the end of the jawline and the beginning of the back of the skull meet.

Fill out the arms with dimensional lines, noting overlap where the arms are bent.

> 4 <

In this drawing the demon will be slightly hunched over, so the boxes representing his head, chest and hips form a slight curve.

>1<

>2<

Lightly sketch out some simple lines and circles for the arm and leg positions.

If you want your demon to have animal-like feet, add an elongated ankle.

>5<

Give the legs the same treatment. If you want them to be normal legs, simply end with human feet instead of talons.

>6<

Draw in an extra set of arms with simple elbow joints and the fingers that will be a pair of bat wings (see page 93).

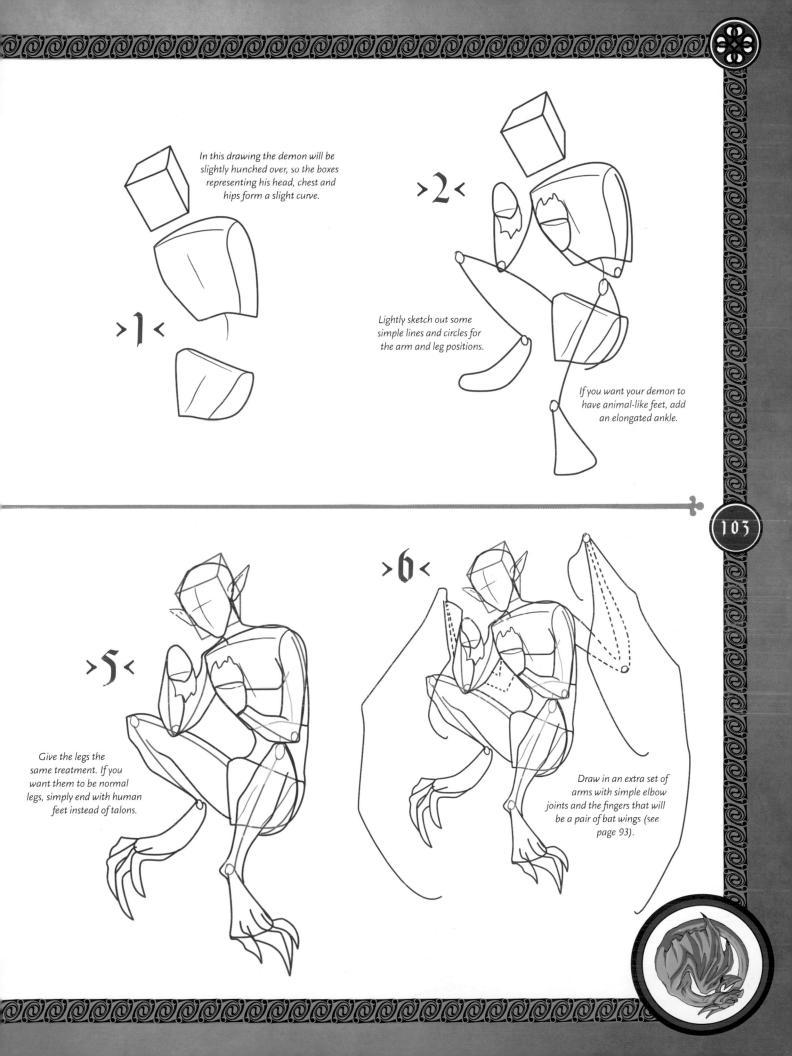

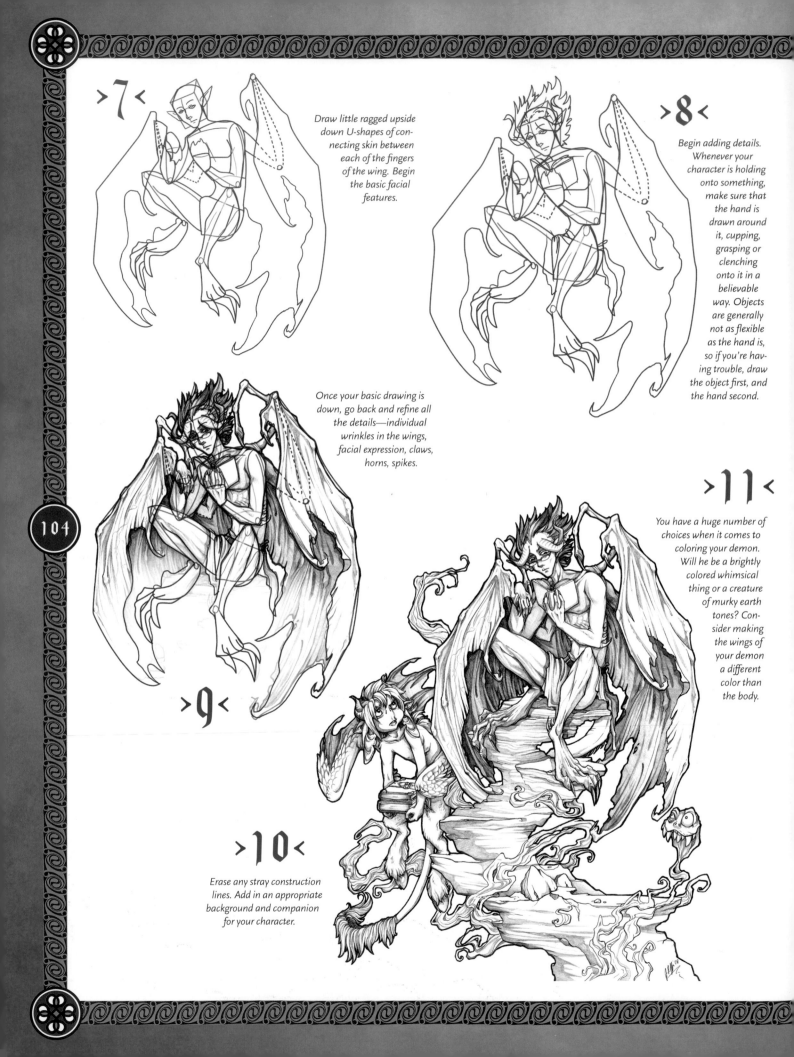

>7<

Draw little ragged upside down U-shapes of connecting skin between each of the fingers of the wing. Begin the basic facial features.

>8<

Begin adding details. Whenever your character is holding onto something, make sure that the hand is drawn around it, cupping, grasping or clenching onto it in a believable way. Objects are generally not as flexible as the hand is, so if you're having trouble, draw the object first, and the hand second.

Once your basic drawing is down, go back and refine all the details—individual wrinkles in the wings, facial expression, claws, horns, spikes.

>11<

You have a huge number of choices when it comes to coloring your demon. Will he be a brightly colored whimsical thing or a creature of murky earth tones? Consider making the wings of your demon a different color than the body.

>9<

>10<

Erase any stray construction lines. Add in an appropriate background and companion for your character.

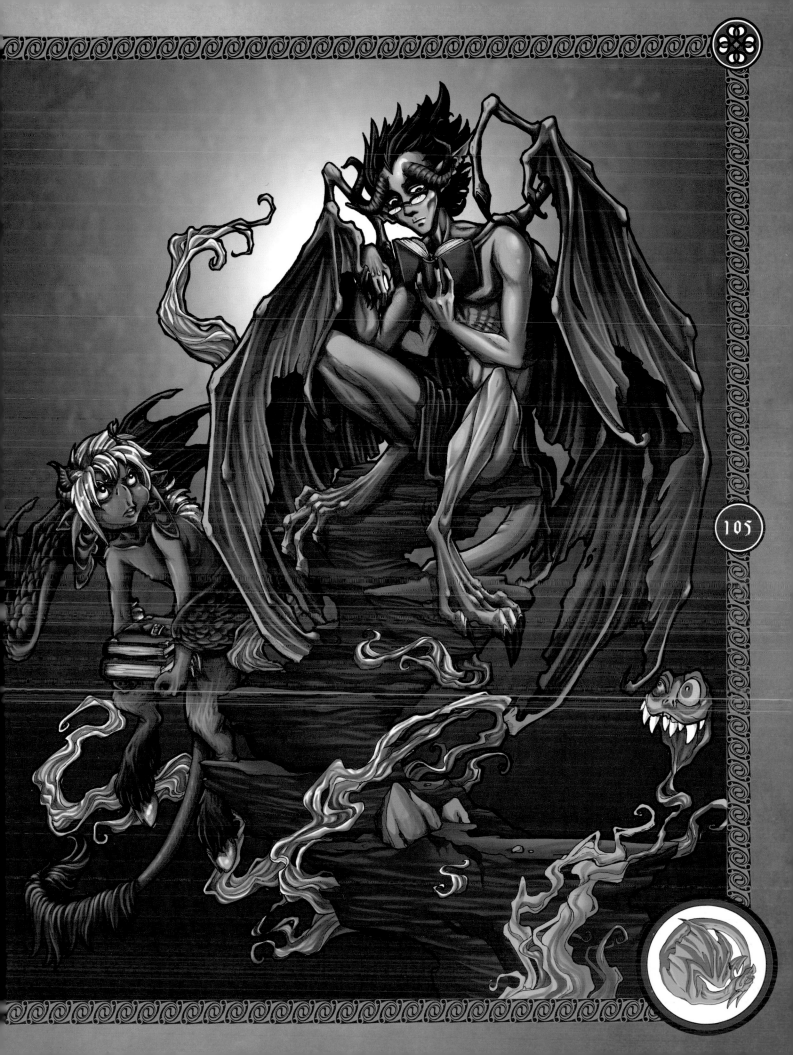

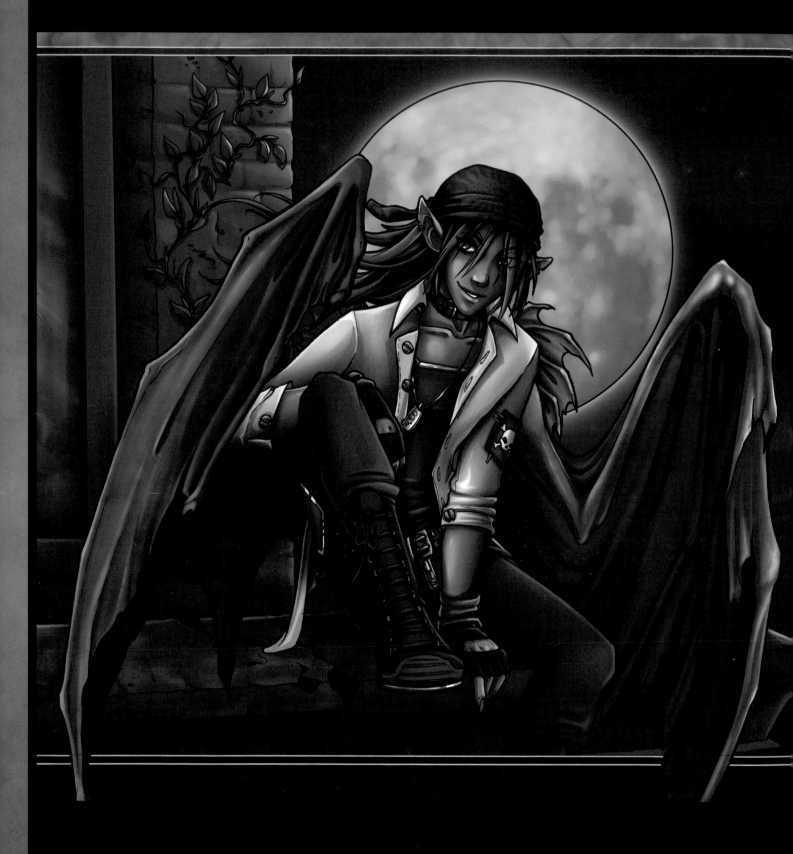

part

4

FASHION
CENTRAL

Costuming is an important part of giving your fantasy characters their identity. It can be used to differentiate a pirate and a knight, or it can be used to play with clichés. A character in a drab, dusty tunic may be a poor peasant or he could be a prince in disguise! Use the visual clues of costuming to make the viewer give your character a second glance.

Warrior

Warriors are very common, but very important fantasy world members. These adventurers have decided that in a world of myth and magic, a good old axe or sword is the most reliable weaponry. Wearing heavy, protective armor and wielding weapons both large and small, warriors can take a hit and fend off the enemy long enough for your fantasy gang to flee, or make some super fun and dramatic plot-twisting realization about who the bad guy is!

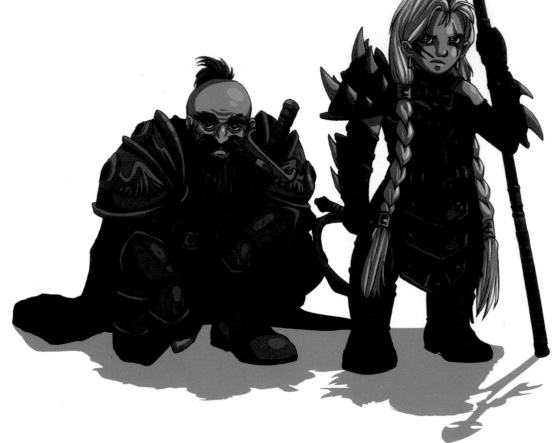

Shoulder Guards

Okay, in real life shoulder guards aren't these big, ornate contraptions. They're small and to the point. In fantasy, shoulder guards can be drawn to look really unique and will greatly influence the look of your character's garb. Whether the guards are simple shapes with intricate detailing or giant, layered shoulders covered in spikes, they'll definitely give the impression of a warrior. If it looks cool, do it!

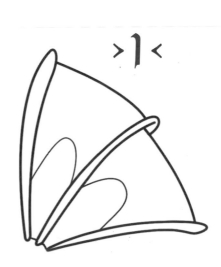

>1<

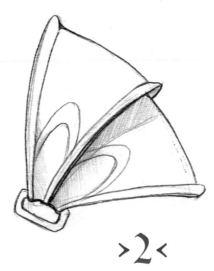

>2<

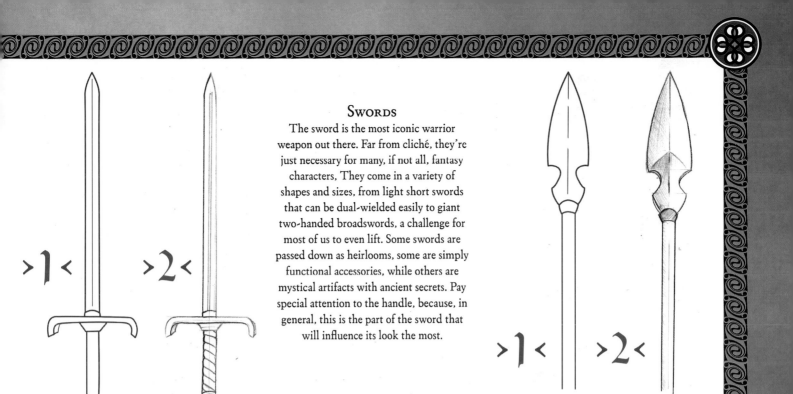

Swords

The sword is the most iconic warrior weapon out there. Far from cliché, they're just necessary for many, if not all, fantasy characters, They come in a variety of shapes and sizes, from light short swords that can be dual-wielded easily to giant two-handed broadswords, a challenge for most of us to even lift. Some swords are passed down as heirlooms, some are simply functional accessories, while others are mystical artifacts with ancient secrets. Pay special attention to the handle, because, in general, this is the part of the sword that will influence its look the most.

Pole Arms

Pole arms are long, dangerous weapons that give your character a fantastic reach. They also make great props for guards and other characters when a sharp axe or double-edged sword simply won't do. Spearheads come in a variety of lengths. When you draw the head make sure that both sides are a near-perfect mirror of each other.

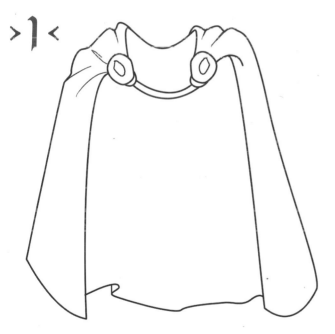

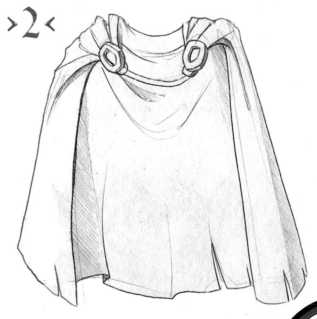

Capes

A great billowing cape can add a lot of drama to your character. Remember that fabric bunches when it's pulled and fold lines will flow in the direction of the fabric's pull. Fabric also lays close to surfaces supporting it, and drapes downward where it's unsupported.

Ranger

 Camouflage is very important to a ranger. Generally human, elf or a combination of creatures, they live outside the confines of a city. They may be part of a group of bandits who stake out the wilderness or self-appointed guardians of the forest. Either way, sticking to a palette of earth tones and greens will go a long way towards making your characters believable.

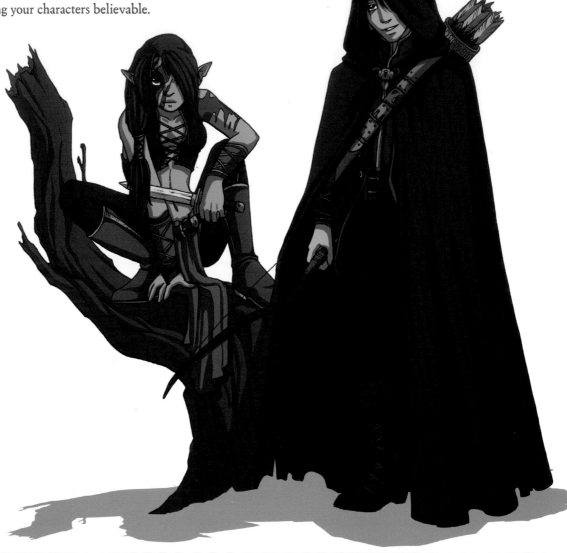

BRACERS

Bracers are relatively easy to draw. They will wrap around the lower arms of your character, so a curved line along each edge will help give a sense of dimension. The bracers may have exposed laces where they tie up.

Arrows

Arrows are delicate, tricky things to draw. The head of the arrow can be made of stone, metal or simply sharpened wood. Use a ruler for the shaft so that it looks nice and straight. Your ranger would have a hard time shooting a crooked arrow! The fletching at the end can be ragged or perfectly aligned, depending on how tidy you want your hunter to be.

>1< >2<

Bows

Bows are the most common ranger weapon. They allow rangers to stay hidden, high up in the trees or behind a bush, out of sight, so that they can take out their enemies from afar. The bow itself is a simple shape, but it can be tweaked a little bit from character to character, giving each bow its own style. Remember that regardless of its shape, it will still need to be held and it will still have to have space for a drawstring.

>1< >2<

Quivers

All those arrows have to go somewhere. If your character is running around with a bow and arrow, it only makes sense that he or she would also have a quiver of arrows strapped on tightly. Quivers come in a variety of different shapes, but they are all essentially tubes.

>1< >2<

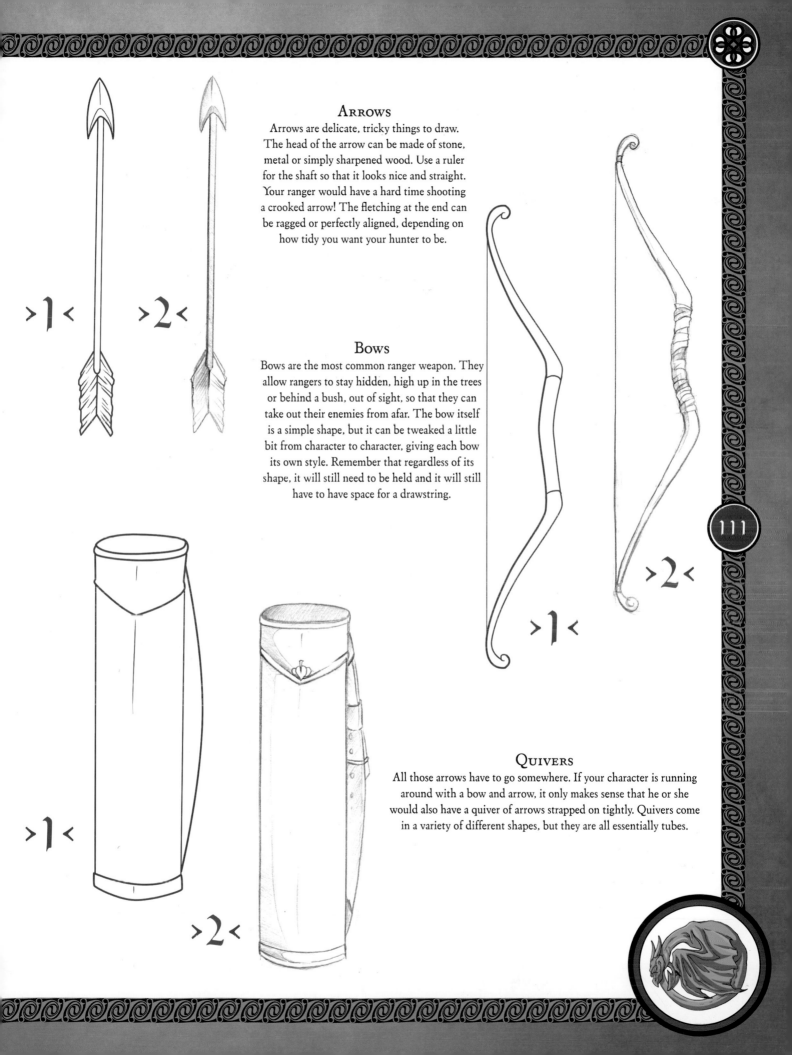

Rogue

Rogues are a common fantasy class that is full of your not-so-perfect heroes. Comprised of cat burglars, pickpockets, pirates and the rest of fantasy society's delinquents, these characters have little respect for rules. Ninety-nine percent of the time, rogues will look out for number one, often leaving the rest of your fantasy gang high and dry. The other one percent of the time, they will pull off surprising, selfless heroics, leaving everyone horribly confused.

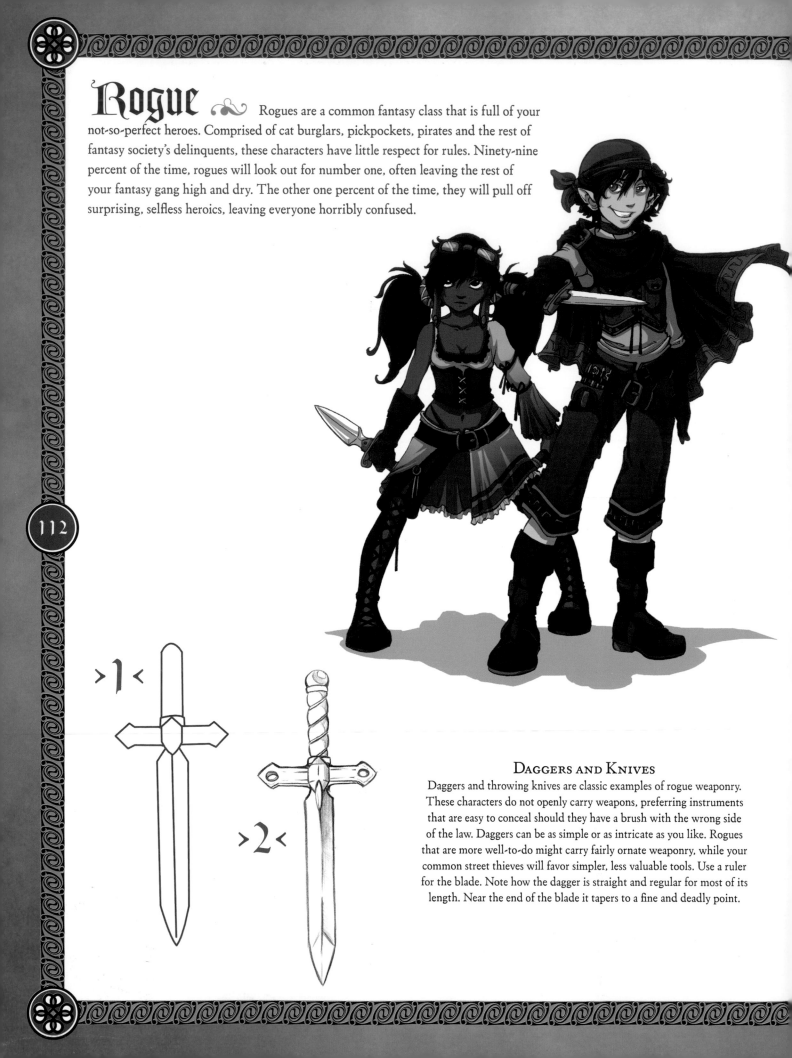

>1<

>2<

DAGGERS AND KNIVES

Daggers and throwing knives are classic examples of rogue weaponry. These characters do not openly carry weapons, preferring instruments that are easy to conceal should they have a brush with the wrong side of the law. Daggers can be as simple or as intricate as you like. Rogues that are more well-to-do might carry fairly ornate weaponry, while your common street thieves will favor simpler, less valuable tools. Use a ruler for the blade. Note how the dagger is straight and regular for most of its length. Near the end of the blade it tapers to a fine and deadly point.

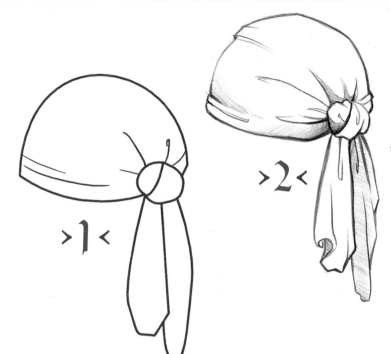

BANDANAS AND HEAD WRAPS

Useful for holding back all that pesky hair when working over a lock or for use as a mask to conceal identity, a bandana makes a fantastic accent for your rogue's outfit. When drawing a bandana, the cloth will be tightly wrapped around the head, taking its shape. A few wrinkles may branch out from the knot on the back.

>1<

>2<

SATCHELS

Many rogues are thieves, and thieves steal a lot of stuff, and that stuff has to go somewhere. Even if your rogue is not a thief, he or she still needs lock picks, flash powder or other goods of the trade. A simple bag with a lumpy or boxy shape with a flap pulled over to secure it is best. It could button shut, buckle shut or be tied shut.

>1<

>2<

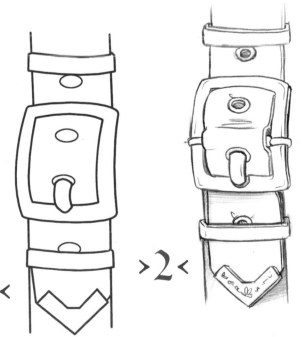

>1<

>2<

BUCKLES AND BELTS

Rogues use belts to hold multiple tools, such as knives, lock picks and perhaps a purse of coin or three, depending on if they've had a successful evening. Because they are so intricate, belt buckles can be intimidating to draw. Simplify the buckle into a hollow rectangle. Overlap one end of the belt over the other and include a strip of metal or leather near the edge so that the end of the belt doesn't flap about.

Mage

Masters of magic and all that is explosive and sparkly, mages and wizards are an important part of most fantasy worlds. These arcane masters know the rhyme and reason behind all the crazy things that can happen in your fantasy world, and they use this knowledge to pull off a few crazy stunts of their own! Mages can be dressed in anything from rich, whimsical robes to a simple tunic and britches.

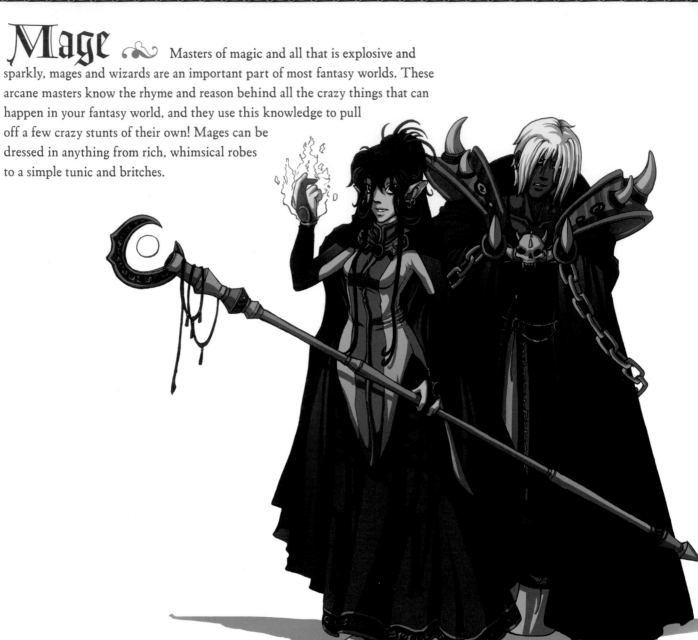

SPELLBOOK

Many mages have a book of spells that they read from when they cast a spell. When drawing your book, consider adding details to it to make it look intricate, thick and special. Books in many fantasy worlds would be hard to come by, let alone contain magical mysteries. As such, if your character happens to own one, it's probably very decked out in metal and leatherwork to protect what's inside.

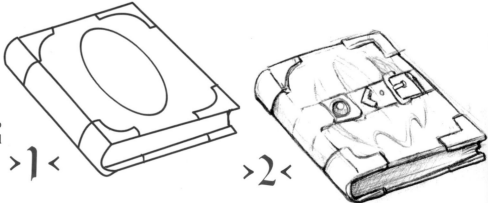

>1< >2<

STAFFS

Mages often carry intricate looking staffs that they use to channel their magic. A staff can be very ornate and delicately crafted or completely natural. Draw a natural-looking stave with an organic, irregular outline. Then add delicate lines showing knots in the wood and paths that the grain follows.

>1< >2<

HATS

A floppy wizard hat is one of the most iconic costuming pieces you can add to your mage. The hat may be tall and pointy. It can also be battered and flopped over, having seen better days if the mage is well travelled. The brim of the hat may still be stiff even if the point of it is not, or vice versa.

>1<

>2<

FAMILIAR

Your sorcerers may have a creature companion to accompany them on their journey. Mages are very wrapped up in their magic, so the creature itself may be just as magical. Consider the personality of your familiar. Is it a cute and cuddly companion, or a sly trickster with ulterior motives?

>2<

>1<

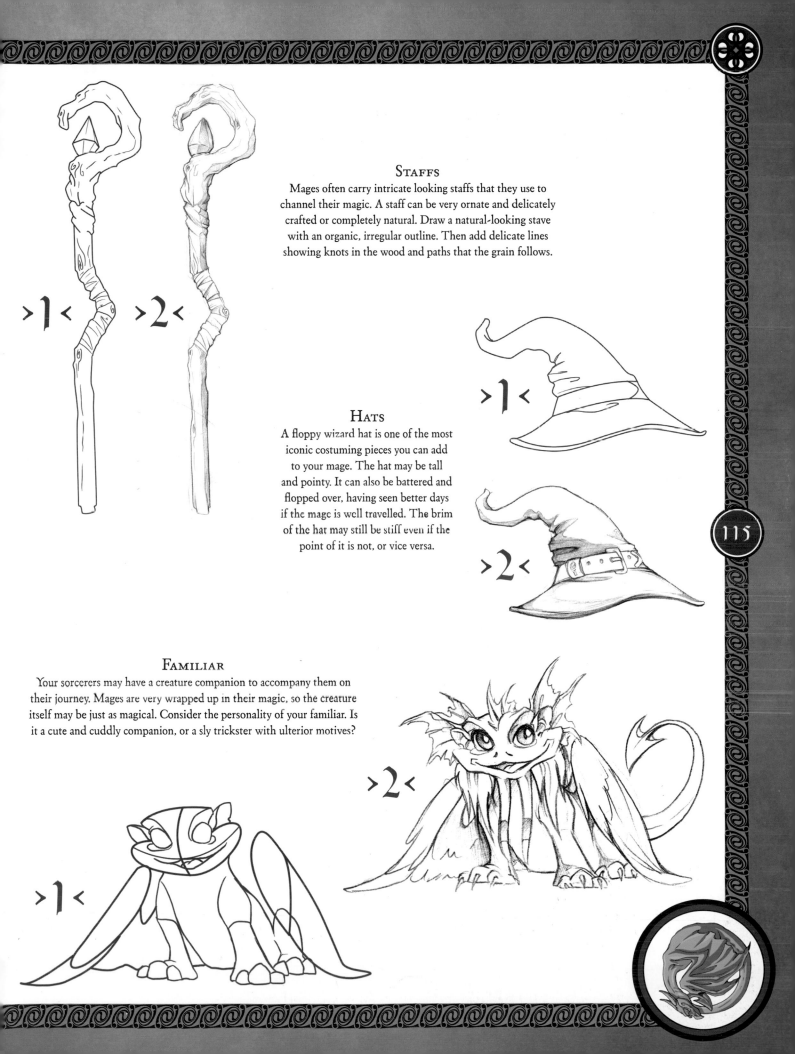

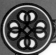

Cleric

A fantasy world can be a dangerous place. What with the dragons, bandits, swords and all. Luckily for them, there's usually a cleric not too far behind, ready to heal wounds or say a little prayer.

Circlet

Accessorizing your cleric's head can be done with a variety of hats, but also consider using a circlet. The circlet could be delicate and thin or a thick metal band.

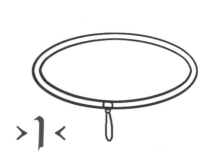

>1<

>2<

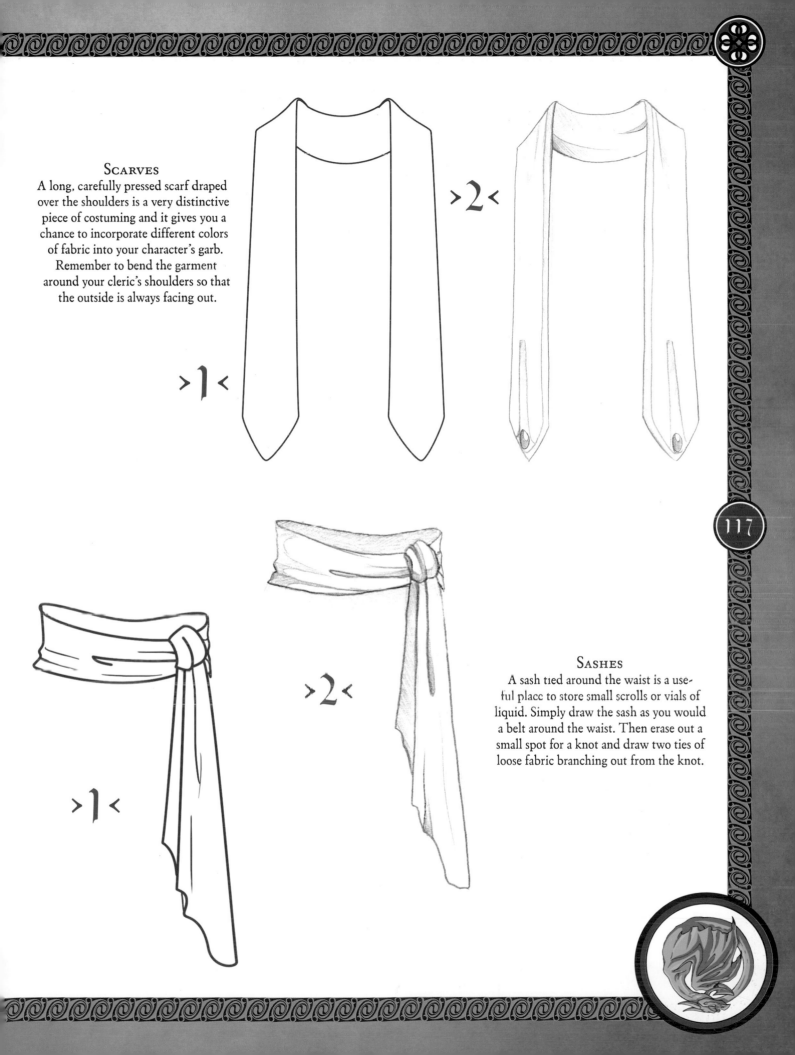

SCARVES

A long, carefully pressed scarf draped over the shoulders is a very distinctive piece of costuming and it gives you a chance to incorporate different colors of fabric into your character's garb. Remember to bend the garment around your cleric's shoulders so that the outside is always facing out.

>1<

>2<

SASHES

A sash tied around the waist is a useful place to store small scrolls or vials of liquid. Simply draw the sash as you would a belt around the waist. Then erase out a small spot for a knot and draw two ties of loose fabric branching out from the knot.

>1<

>2<

Samurai

Fantasy worlds are more diverse than our own. Not only do you have human culture to deal with, but that of elves, orcs and other fantasy races. You can of course create your own unique set of styles for each race, or you can draw upon the rich diversity present in human history to use as inspiration for creating different cultures for your races. Drawing from Eastern culture is a great way to give a new twist to your warriors and mages.

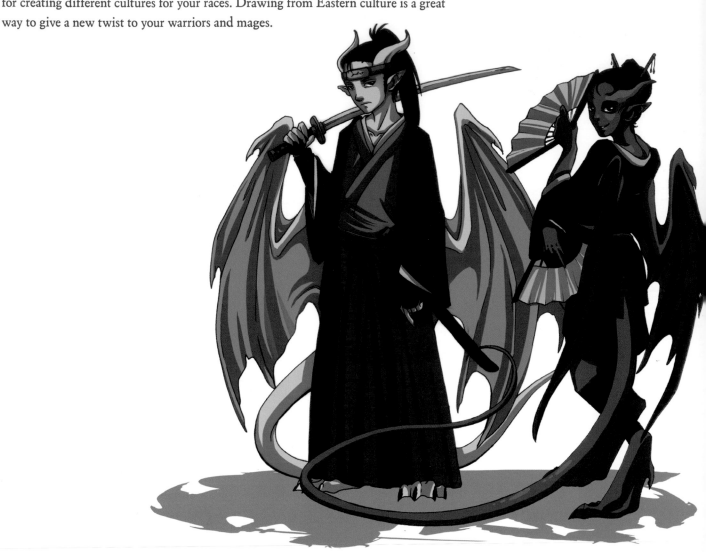

KUNAI AND THROWING STARS
Samurai need a variety of throwing weapons, and kunai and throwing stars fit the bill. These small but deadly weapons are made of simple shapes and can really be used to dramatic effect when drawn in the midst of a battle.

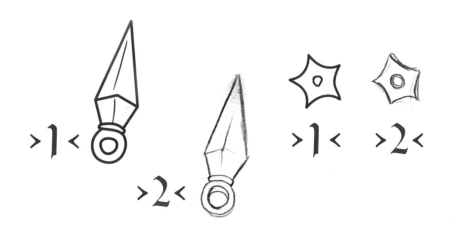

CONICAL STRAW HATS

Pointy hats are great for keeping your character cool in the midday sun. They are equally useful for hiding the identity of the mysterious stranger passing through town, head hung low. When drawing a pointy hat, remember that it does not just sit way on top of your character's head. It will partially obscure a section of the skull. Add a drawstring to ensure that the hat does not topple off your character's head.

>1<

>2<

FANS

Fans are an elegant, mysterious accessory that any character can use. A fan can mask a face or hide a dagger. Begin with a series of evenly spaced sticks branching out from the center point, where the fan folds together. Connect these sticks with two strips that follow the edges of the fan down to a point a little over halfway down. Leave a small amount of the wooden sticks exposed to give your character a place to hold the fan.

>1<

>2<

>1<

>2<

KATANA

Eastern swords are very distinctive in design. Take this into account when you're drawing your katana. Do you want a curved or straight blade? How long is the blade? What is the length of the handle? Will it be used for decorative purposes, for combat, or for both?

Nobles

Nobility and the upper class usually dress in finer garb than the rest of populace. Even if your characters are not members of the nobility themselves, encounters with nobles are a great chance to explore some lavish costuming and settings.

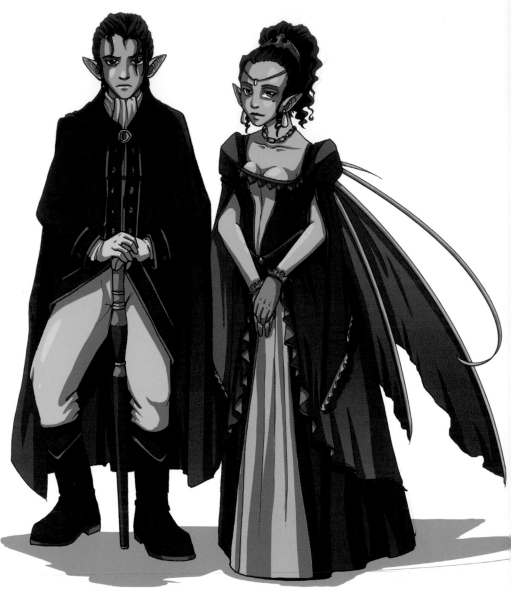

Jewelry

Few things get across a lavish display of wealth as well as jewelry. Bedeck your nobles in necklaces, rings, bracelets, pins, fancy buttons and earrings. When drawing jewelry, the trick is to make it specific enough that you know what it is, while not going overboard with detail or there will be too much packed into a small space, which will detract from the rest of your drawing.

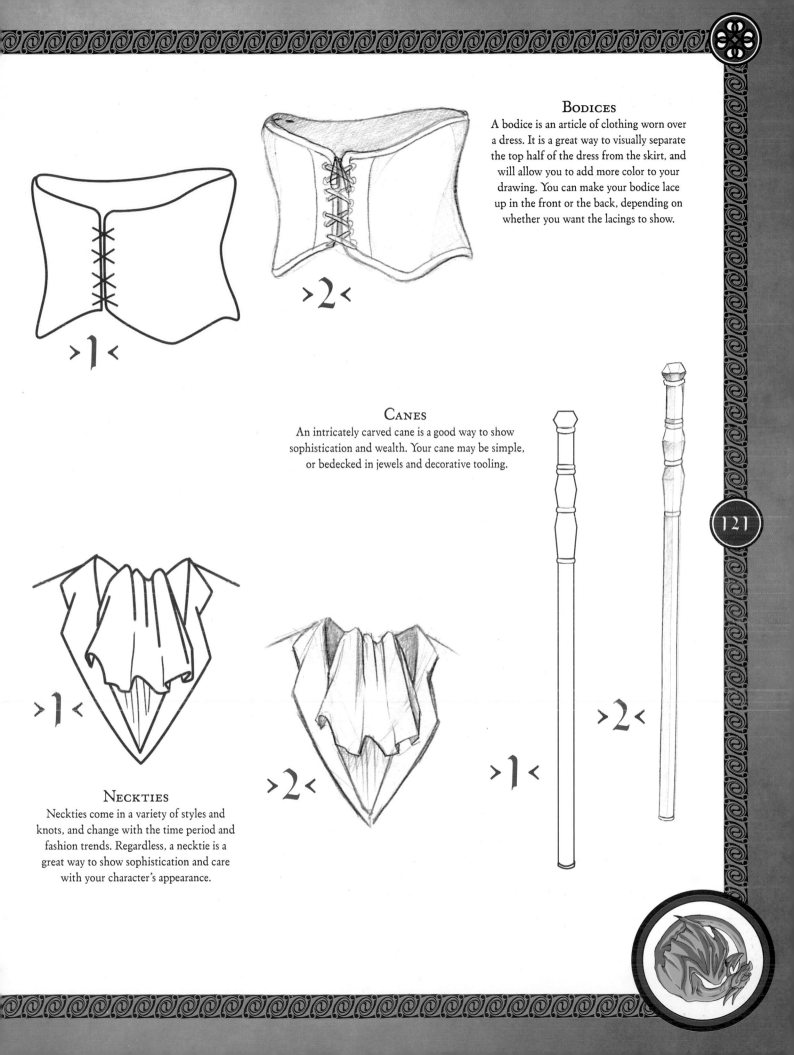

BODICES

A bodice is an article of clothing worn over a dress. It is a great way to visually separate the top half of the dress from the skirt, and will allow you to add more color to your drawing. You can make your bodice lace up in the front or the back, depending on whether you want the lacings to show.

>1<

>2<

CANES

An intricately carved cane is a good way to show sophistication and wealth. Your cane may be simple, or bedecked in jewels and decorative tooling.

>1<

>2<

>1<

>2<

NECKTIES

Neckties come in a variety of styles and knots, and change with the time period and fashion trends. Regardless, a necktie is a great way to show sophistication and care with your character's appearance.

Peasants

In a world of wizards and dragons, peasants may not seem like the most interesting thing around. . . they're so ordinary. I mean, come on, that little twerp can't throw a fireball or fly. But wait. If everyone in your world can fly and throw fireballs, then what makes these magical powers extraordinary? How much more dramatic is it if your hero-to-be started off with nothing and realized he or she was destined for great things? Heck, maybe your peasant never does become a hero. A peasant's story might be about being an ordinary person, surviving in a world where everything else is dangerous and powerful.

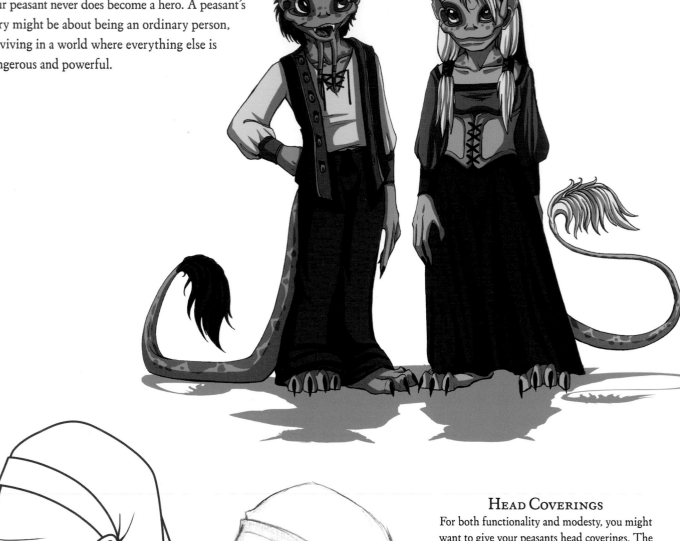

>1<

>2<

HEAD COVERINGS

For both functionality and modesty, you might want to give your peasants head coverings. The shape and color of your hat will go a long way towards making your character unique in a class known for its simple clothing and drab colors.

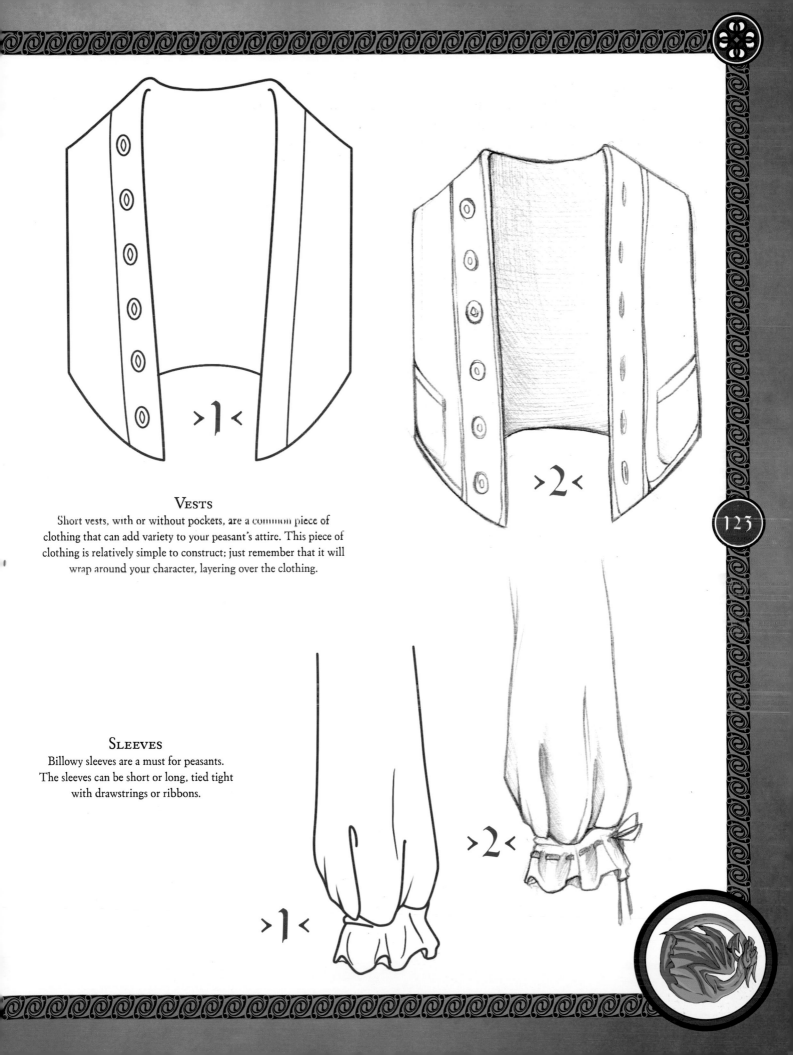

Vests

Short vests, with or without pockets, are a common piece of clothing that can add variety to your peasant's attire. This piece of clothing is relatively simple to construct; just remember that it will wrap around your character, layering over the clothing.

>1<

>2<

Sleeves

Billowy sleeves are a must for peasants. The sleeves can be short or long, tied tight with drawstrings or ribbons.

>1<

>2<

FANTASY IS. . .FANTASTIC?!

Fantasy is a great genre to draw in, because you can draw anything you want, and tell stories without limitations! Remember this, and don't let this book limit you. There are some good ideas and foundations in here, but these tutorials alone are not what is going to create amazing, imaginative art: It's you! Take what you've learned and let your imagination and characters go whatever direction they would like to take you!

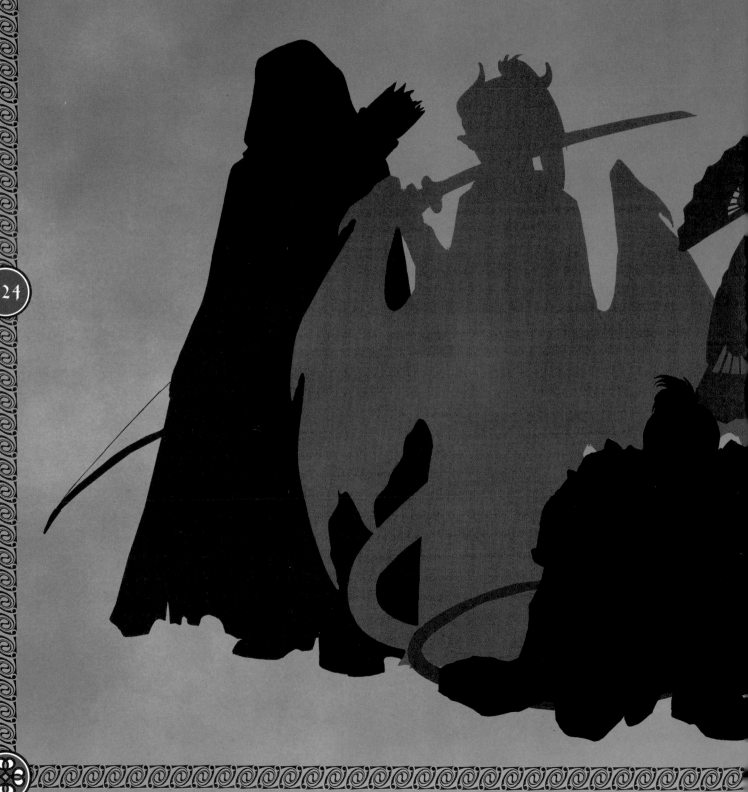

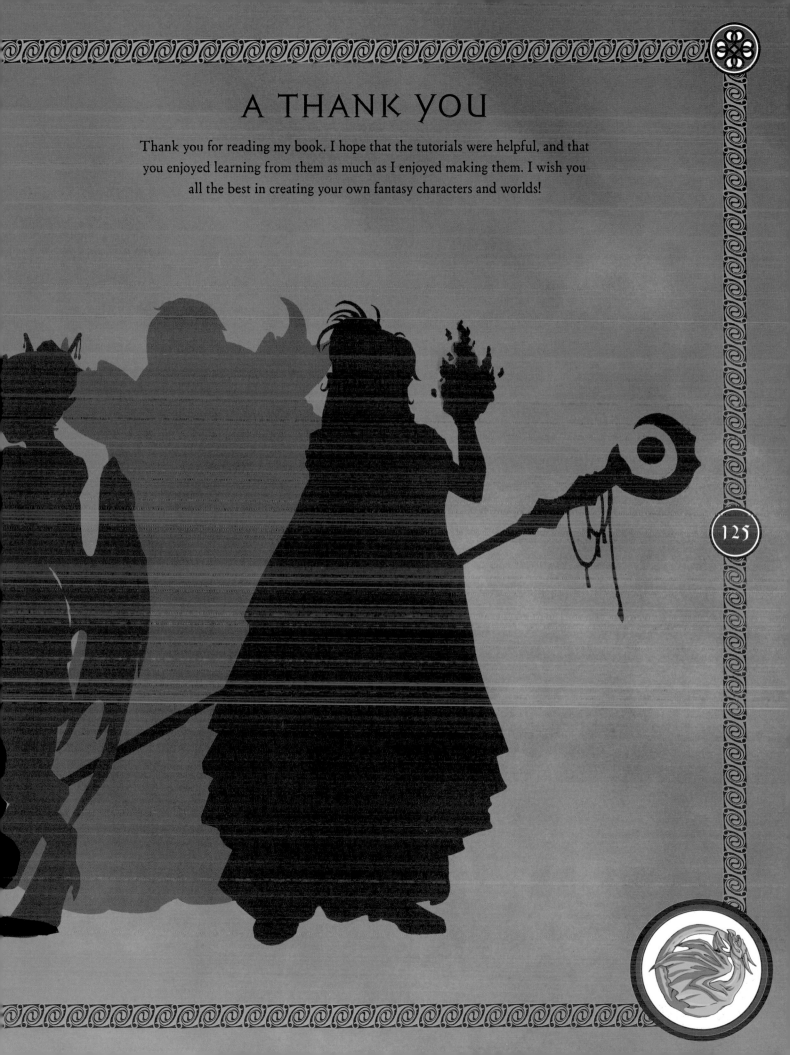

A THANK YOU

Thank you for reading my book. I hope that the tutorials were helpful, and that
you enjoyed learning from them as much as I enjoyed making them. I wish you
all the best in creating your own fantasy characters and worlds!

Index

IF YOU'RE GOING TO DRAW,
DRAW WITH IMPACT!

Nothing makes the imagination catch fire like the dragon, one of the most enduringly popular beasts of legend. Now you can learn simple secrets and tricks for creating your own dragon artworks. Let your imagination soar as you bring majestic dragons and other mythical creatures to life using J "NeonDragon" Peffer's easy-to-follow progressive line art demonstrations.

ISBN-13 978-1-58180-657-1
ISBN-10 1-58180-657-4
paperback; 128 pages; #33252

Discover how to sketch, draw and color your own fantasy worlds with *Fantastic Realms*! This instructive guide gives you over forty lessons for creating characters, creatures and settings. Complete with an appendix to help you invent your own characters and scene characteristics, you'll soon be on your way to bringing your fantasy world to life.

ISBN-13: 978-1-58180-682-3
ISBN-10: 1-58180-682-5
paperback; 128 pages; #33271

Discover how to draw and paint the amazing, dynamic array of characters, creatures and landscapes with this absorbing and practical guide. You'll learn to draw and paint fantasy subjects and render realistic details such as expression and movement. You'll also find stunning finished illustrations by top fantasy artists such as Bob Hobbs and Anthony S. Waters enabling you to see the process from sketches to amazing finished works!

ISBN-13: 978-1-5818-0907-7
ISBN-10: 1-5818-0907-7
paperback; 128 pages; #Z0534

Buddy Scalera is a comic and graphic novel writer who's worked on Marvel Knights and *X-Men* projects for Marvel, as well as titles for Mad Science Media, Penny Farthing Press, and more. He's created the ultimate compendium packed with reference photos of men and women in basic and dramatic super-hero poses, all uniquely tailored for your needs as a comic artist. No matter what your skill-level, you can draw from a variety of models in all kinds of poses, any time you want!

ISBN-13 978-1-58180-758-5
ISBN-10 1-58180-758-9
paperback; 144 pages; #33425

THESE BOOKS AND OTHER GREAT IMPACT TITLES ARE AVAILABLE AT YOUR LOCAL BOOKSTORE OR FROM ONLINE SUPPLIERS.

128